GLASS HOUSE

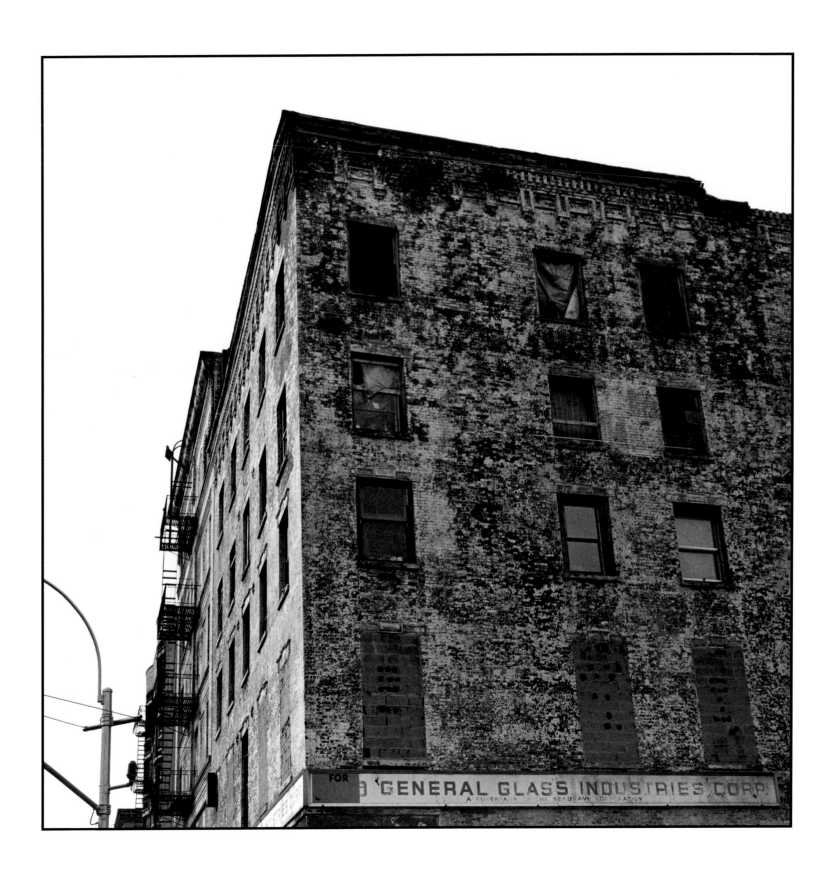

GLASS HOUSE

Margaret Morton

The Pennsylvania State University Press | University Park, Pennsylvania

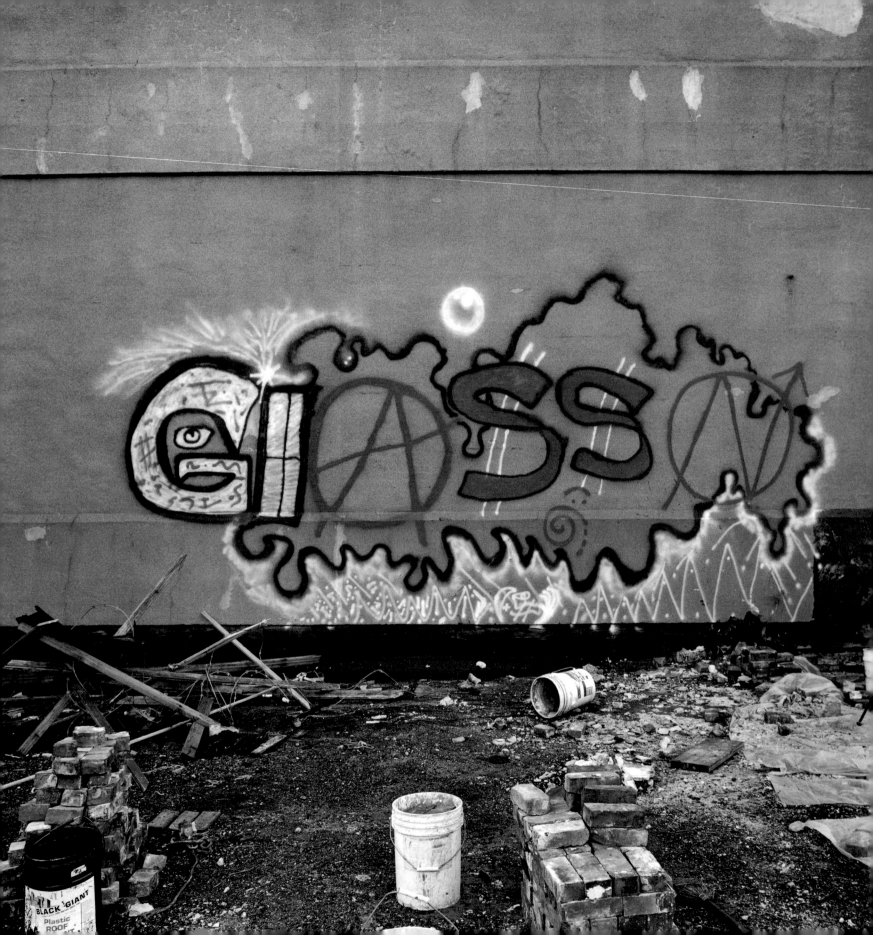

I'D RATHER HAVE ADVENTURES THAN THINGS,

BECAUSE ONCE THE ADVENTURE IS OVER,

NOBODY CAN EVER TAKE IT AWAY FROM ME.

DONNY

LIBRARY OF CONGRESS CATALOGING-IN-PUBLICATION DATA

Morton, Margaret.
Glass house / Margaret Morton.
p. cm.
ISBN 0-271-02463-1 (alk. paper)
1. Documentary photography—New York (State)—New York.
2. Homelessness—New York (State)—New York—Pictorial works.
3. Homelessness—New York (State)—New York.
4. Homeless persons—New York (State)—New York—Interviews.
5. Squatters—New York (State)—New York—Interviews.
6. Morton, Margaret.
I. Title.

TR820 .5 .M678 2004
305.235'086'942097471—dc22
2004002205

COPYRIGHT © 2004 OmbraLuce LLC
All rights reserved
PHOTOGRAPHS AND TEXT Margaret Morton
Printed in the United States of America
PUBLISHED BY The Pennsylvania State University Press,
University Park, PA 16802-1003

The Pennsylvania State University Press is a member of the
Association of American University Presses.

It is the policy of The Pennsylvania State University Press to
use acid-free paper. Publications on uncoated stock satisfy the
minimum requirements of American National Standard for
Information Sciences—Permanence of Paper for Printed Library
Materials, ANSI Z39.48–1992.

CONTENTS

LOWER EAST SIDE	1
OCTOBER 10, 1992	4
A GLASS FACTORY	7
DUMPSTER DIVING	32
HOUSE RULES	34
ON WATCH	36
COMMUNAL LIVING	46
DISPUTES	48
DRUGS	50
STORIES	
KIM	55
CHAD	59
MOSES	65
LISA	70
SCOTT	75
MERLIN	80
HEIDI	85
JOHN	92
ANGELA	94
CALLI	101
LINDA	109
TOBY	113
ERICA	120
KARL	127
DONNY	130
PREMONITIONS	137
FEBRUARY 1, 1994	138
EPILOGUE	145
AUTHOR'S NOTE	150
ACKNOWLEDGMENTS	151

PHOTOGRAPHS

Tyrone 14
Chad 14, 25, 31, 58
Lisa 15, 68, 69, 71
Donny 18, 131
Erica 19, 119, 121
Calli 20, 33, 100, 143
Scott 22, 35, 74
Angela 27, 28, 95, 143
Markus 27, 28
Garth 31, 88
Toby 33, 112, 119
Heidi 35, 84
Kim 54, 57
Moses 64
Merlin 81, 147, 148
Mark [Gentle Spike] 89
John 93
Resident 105
Exodus 106, 107
Linda 108
Karl 126
Joeleyn 142
Maus 143

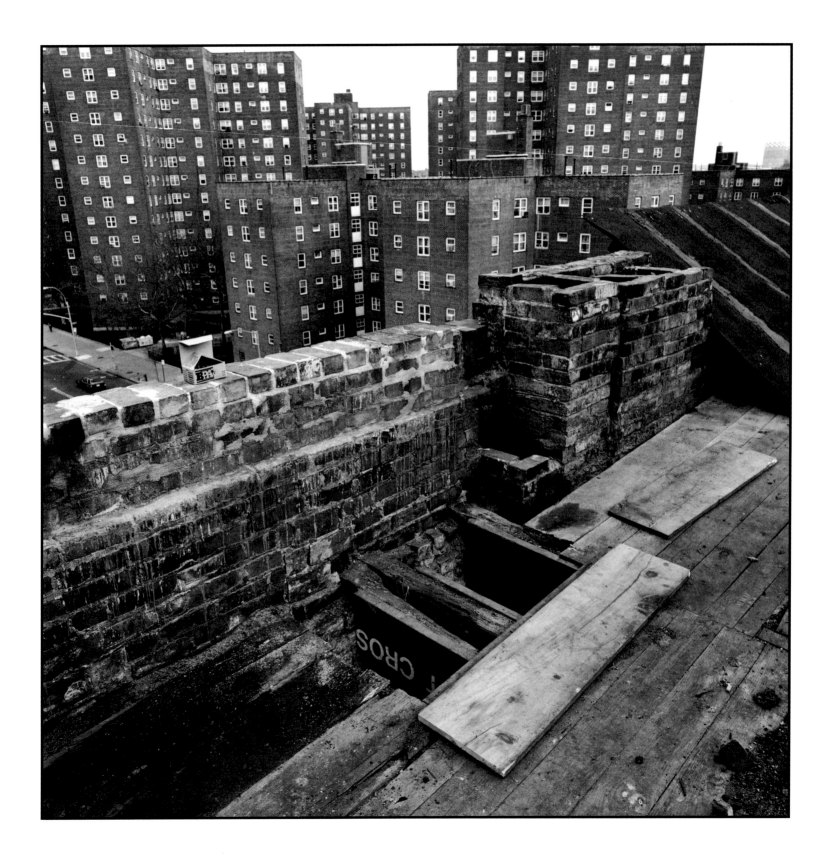

LOWER EAST SIDE

Just before the island of Manhattan narrows into a slender tip, an expanse of land juts into the East River. In 1811, when the city commissioners established a street grid for the growing metropolis of New York, the area posed a problem: it could not be integrated into the plan to have twelve long, straight avenues organize the city. Rather than shorten these thoroughfares, the commissioners decided to treat this troublesome stretch of land as a separate entity, divided into fifty-two blocks, with its own system of avenues, designated not by numbers but by letters: A, B, C, and D.

As the City of New York developed, this area east of First Avenue seemed to have a life of its own, marked by dramatic cycles of growth and decay that were accompanied by sharp shifts in identity and nomenclature. Over time, the area accumulated names, which record the passage of one group of immigrants after another.

By the mid-nineteenth century, Avenue B had become "German Broadway," and the neighborhood, which housed one of the world's largest German-speaking communities, was called "Kleindeutschland" or "Little Germany." The opening of Ellis Island, in 1892, marked a second wave of immigration that was to bring new ethnic groups to the area, especially from Eastern Europe. Work was available in the factories that lined Avenue D, and living space was provided in rapidly built tenements, which soon crowded every available tract of land.

When Ukrainian refugees arrived in the 1940s, they settled into what had long been the largest working-class area in Manhattan and was known simply as the "Lower East Side." Puerto Ricans, who began to live on Avenues C and D in the 1950s, preferred the Spanglish "Loisaida."

This slippage in terms registers the changes that were endemic to this section of the city. By the 1970s, many small manufacturers had gone out of business or left the area. At the same time, there was a sudden decline in the housing market and, in 1975, the city underwent a devastating fiscal crisis. Many area landlords found it more profitable to cash in on fire insurance than to try to collect rent from their often-impoverished tenants. A number of landowners defaulted on their tax bills and, once the city assumed ownership, the buildings were allowed to deteriorate.

Even in its decline, the Lower East Side attracted large numbers of artists, musicians, and intellectuals looking for low rents and neighborhoods where they could live free from mainstream expectations and constraints. The number of artists continued to increase, and in the early 1980s art galleries, restaurants, and clubs opened, turning the Lower East Side into an arena of social and cultural experimentation dubbed "Alphabet City." Real estate speculators quickly saw the potential of the "East Village" to become another SoHo, which had been transformed from a rundown manufacturing district into a highly profitable cultural and retail mecca.

The 1987 transformation of a community center, the Christadora House, into the first luxury apartment building in the history of the Lower East Side, marked a turning point in the area's development. The stage was now set for conflict between real estate speculators and other entrepreneurs eager to reap the profits of gentrifying the neighborhood and those residents committed to preserving its life as a haven for the marginal.

By the 1980s the resisters included men and women who had continued to live in foreclosed buildings and those who took up residence as squatters. There also were large numbers of homeless individuals who had set up makeshift dwellings throughout the Lower East Side. By far the most conspicuous of these was an encampment of more than sixty tents sheltering twice as many people opposite the Christadora House in Tompkins Square Park. The ten-acre park soon became a national symbol of the homeless crisis. Police efforts to evict this community often erupted into heated, sometimes violent, conflict. In 1991, having finally evicted the tent city residents, the city closed the park for two years of renovations. Gentrification of the neighborhood rapidly spread east of Avenue B.

The residents of the abandoned buildings, unlike squatters in London or Berlin, whose patterns of settlement are often tolerated and who have certain legal rights, lived in constant jeopardy of being evicted. Nonetheless, they remained, often living without heat, water, or electricity.

OCTOBER 10, 1992

Several of the squatters who would establish the Glass House community first met in the late fall of 1990 in an abandoned apartment building nearby on East Ninth Street. After finding mounds of baby clothes in one of the rooms, they called their new home "Foetus" and began to repair the neglected building. On October 10, 1992, a fire broke out in the ground-floor stairwell of Foetus squat.

Scott It was a nice, sunny Saturday. Everyone was outside. We had eaten a soup-line lunch, then I went back to Foetus. I was working on joint-compounding and taping my ceiling and listening to Sly and the Family Stone on my roommate's tape. I started to smell smoke, then I heard my roommate's voice coming up through the stairs, "Fire, fire! There's a fire downstairs!"

I yelled, "Let's grab a couple of piss buckets and put it out." I started running downstairs with the piss bucket and got no lower than the third floor when I saw flames starting to come up through the joists. I was engulfed in black smoke and I couldn't breathe. I decided I shouldn't go down any further. I'm just going up. I went up to the roof, over to the next building, down through that building and out. People were outside trying to put the fire out. Everything's burning down. Then the cops and the Fire Department come, and we're yelling, "Put the fire out! Put the fire out!" And they're yelling, "Get back! Get away from here!" They just let it burn.

But when the fire started to spread to the building next door and the apartments behind it, they put it out. It was a big fire. The heat was incredible. There were no ceilings to stop it, so it spread really quickly through the back of the building and just went right up to the roof. Someone had kerosene heaters, and all of a sudden there was a big explosion in the back of the building that knocked out windows in the apartments behind it.

The cops wouldn't let us come back to get anything from inside the building—they had guards out in front almost twenty-four hours straight—so we had to sneak in. We had to go through the garden lot on our bellies and crawl up the back of the building, which had been blown up and collapsed, crawling up the debris to get back into the front apartments. I just grabbed a few clothes and some tools and left.

Kim People said, "You want to come? You can live at Glass House."

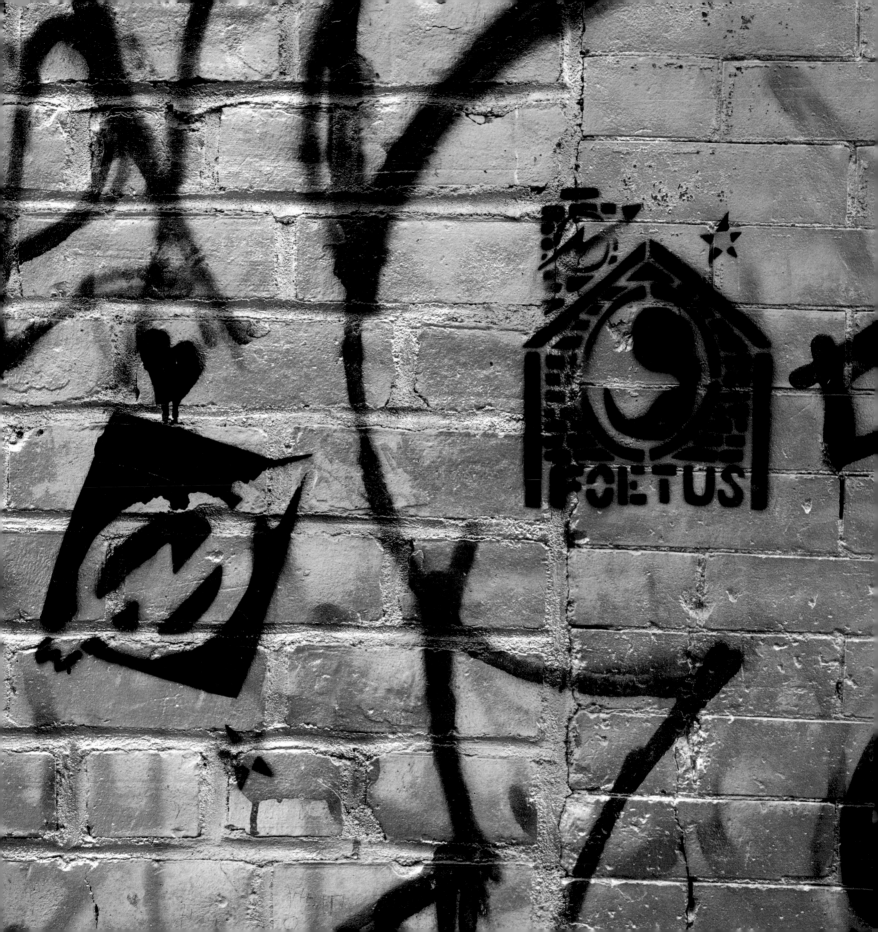

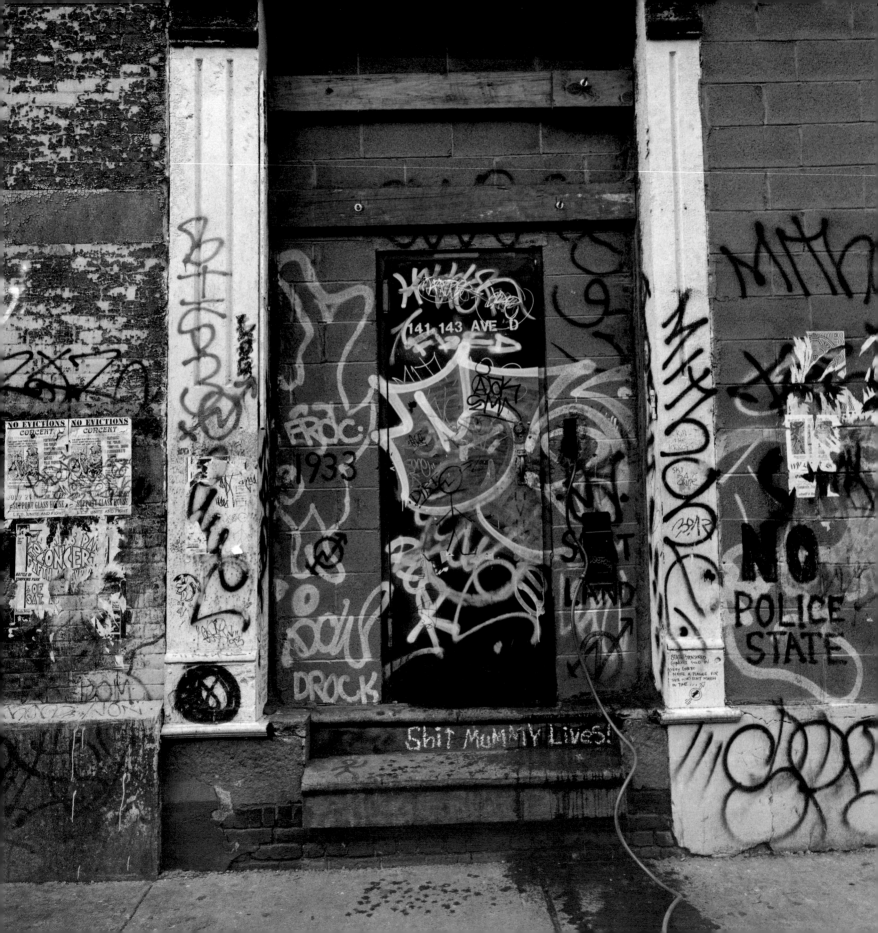

A GLASS FACTORY

After fire destroyed the abandoned apartment building in which they had been living, several of the squatters from Foetus arrived at a deserted factory on the southwest corner of Avenue D and East Tenth Street.

General Glass Industries Corporation had vacated these attached five- and six-story brick buildings by 1973, and the factory, which had teemed with light manufacturing activity since the early 1900s, quickly fell into decay. Drug addicts and alcoholics increasingly used the buildings as a crash pad in the following decades.

The young squatters claimed the massive space as their own, clearing piles of debris, constructing walls, and creating living areas for themselves. They called their new community "Glass House."

Calli After Foetus burned down, people moved in here and things started happening. Glass House started to become a real squat and not just a bunch of lazy punks.

Moses Up until then, Glass House had been just a few people who got kicked out of Foetus. Foetus had been the real meeting point for the young squatters of the neighborhood, and, after the fire, Glass House inherited that. A lot of good people came into Glass House from Foetus. Scott came from Foetus. People started organizing themselves. And that's when the change started, too.

Donny When we originally opened the place, there were huge piles of pipes, tons of plastic rubble, and a big mess of garbage—all kinds of junk. There was no electricity. There were no toilets. There were no windows. The six-floor building had a bad roof problem. If we hadn't replaced a couple of joists, the building would have collapsed. You had rotting roofing holding up broken joists rather than the joists holding up the roofing. It never would have survived last winter, let alone all the snow this winter.

The building had existed as a very low-level-activity flophouse where homeless people, winos, drug addicts, whatever, would slip in and out, crash from time to time, get thrown out, then stay there for a while again. This had gone on for years. There were mattresses laying here and there, nests. The building had a really wild time of it the first few months I was there. A couple of people were using it as a crash pad, then other people were moving in and trying to make a serious squat out of it. There were lots of new people flowing in and out every night.

Kim The place was totally trashed. There were no laws. That winter there were so many junkies living there that we just kicked them all out one night. One of the guys came home totally fucked up and was starting shit out in the hallways. We tried to break it up, and he slapped me. I said, "Look, if you slap me one more time, I'm going to have to hurt you." He slapped me again. He was totally wasted, so I just threw him down the stairs, and he went and passed out somewhere.

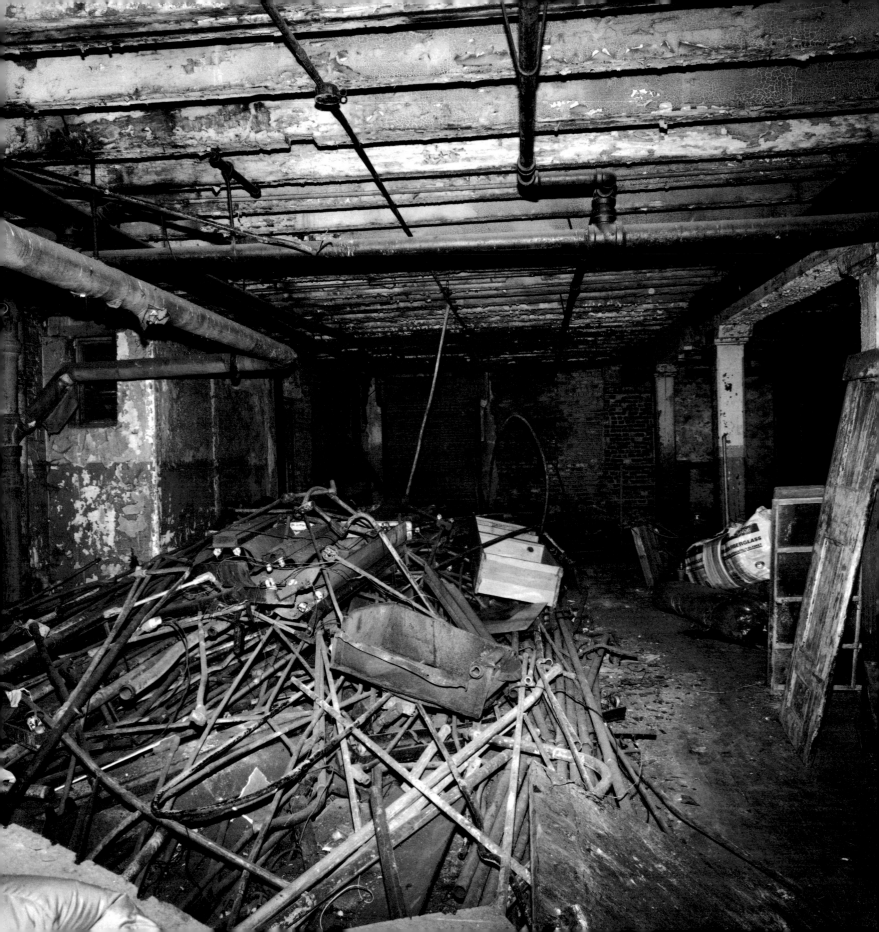

Kim Later on, about six in the morning, one of his friends came back with a baseball bat, smashed my stereo, and hit me and my friend on the head. So we just went around, woke everybody up, went over to C Squat to get more people, and threw all the junkies out. We knocked on their door. They had it barricaded and locked. We told them, "There's twenty-five of us out here. You can either leave peacefully, or it can be a problem." There were only eight or nine of them, so they got their stuff together and we escorted them to the door. We had pipes and two-by-fours, but no one had to use them. The next day they jumped Karl in the park and broke his glasses, but after that they never bothered us again. That was a big turning point for Glass House.

After this stuff happened with the junkies, we were all really close, we got to know each other pretty well. It was a big motivating thing because we had done something that was major, very important. That was when the workdays started rolling. We were having three workdays a week, really working hard. We did a lot of work on the roof because there was a big sinkhole on my side of the building. We went up there, took out all the joists and replaced them. We ran electricity in the hallways.

Donny We got electricity from a street light on the corner. In the middle of the night, we cut a trench in the seam of the sidewalk with a pick. We put the cable in and cemented the whole thing back over by morning.

Chad And every time the "Don't Walk / Walk" sign would blink, our lights would dim.

The squatters hammered through concrete block and mortar to reopen windows that had been sealed shut for twenty years. At night they covered the window openings with black plastic to conceal their electric lamps.

There was no water supply. Residents made nightly trips to a nearby fire hydrant, using a large plumber's wrench to force it open. They installed a kitchen sink, which drained into an empty joint-compound bucket. Glass jars and plastic buckets provided the only toilets for the first few months, until Kim and Moses installed two "bucket flush" toilets on the ground floor.

The building needed constant repairs. The roof was so damaged that rain poured through the upper floors; in winter, icicles hung from the ceilings. Loose bricks fell to the pavement from the crumbling parapet, causing potential danger to passersby and possibly attracting attention from the city's housing agency.

The squatters salvaged discarded building materials from dumpsters and renovation projects. A nearby lumberyard donated warped two-by-fours and drywall. Bright blue planks from police barricades, found alongside construction sites and parade routes, were put to use as replacement stair treads, joists, or trim for loft beds.

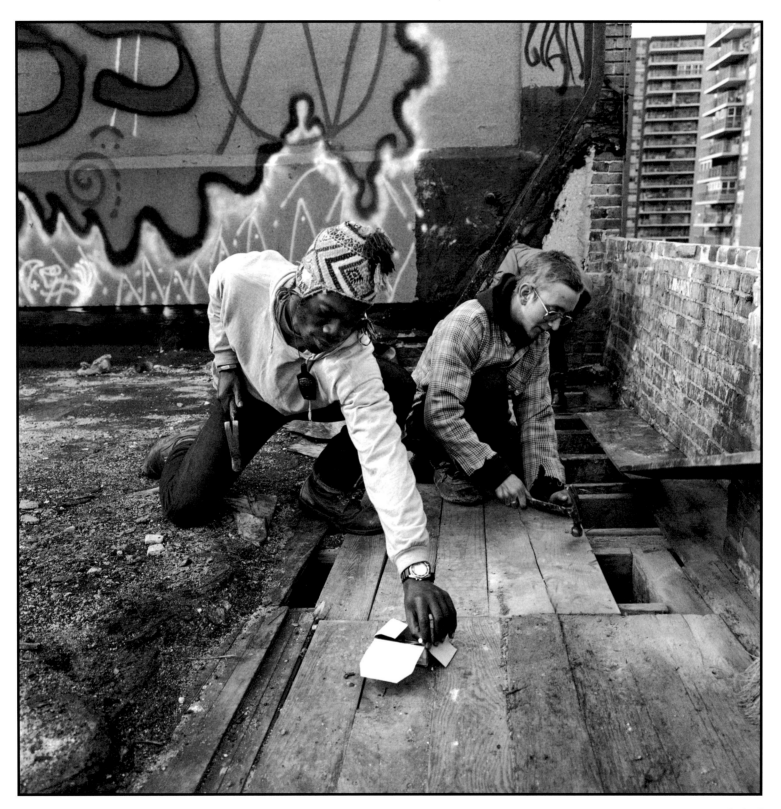

Tyrone and Chad

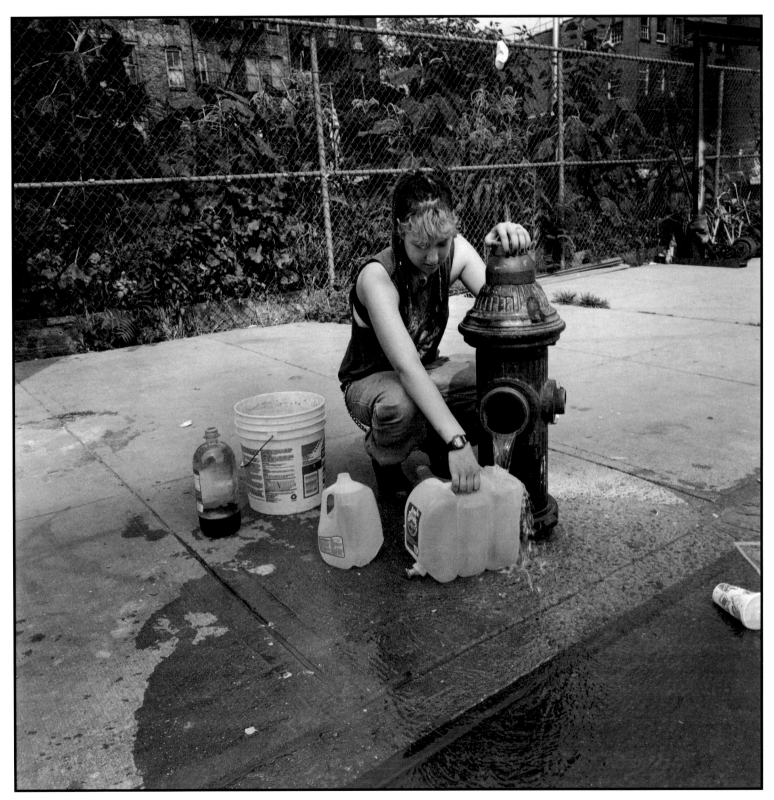

Lisa

> DREAMS FALL
> DREAMERS
> COME AND GO
> BUT the HOPE
> that FUELS the FIRE
> OF OUR GOAL MUST
> NOT DIE OUT!
>
> — EXODUS

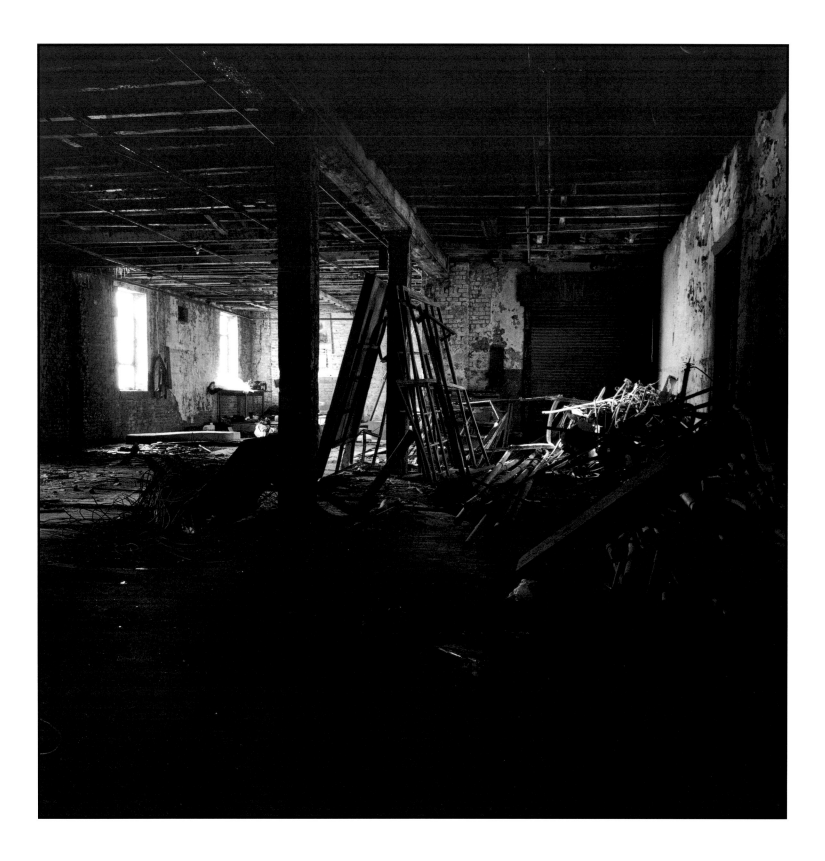

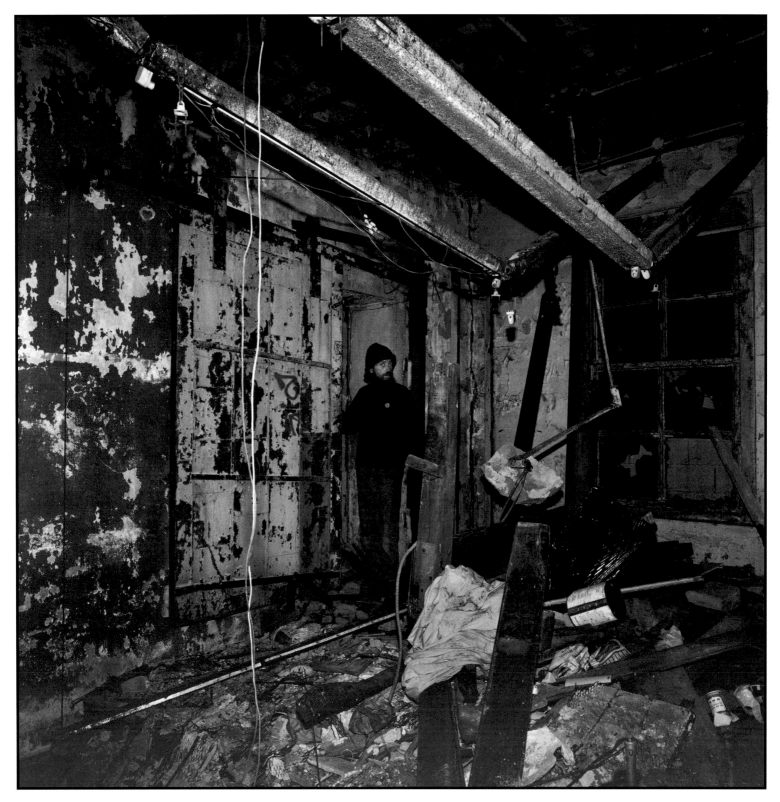

Donny

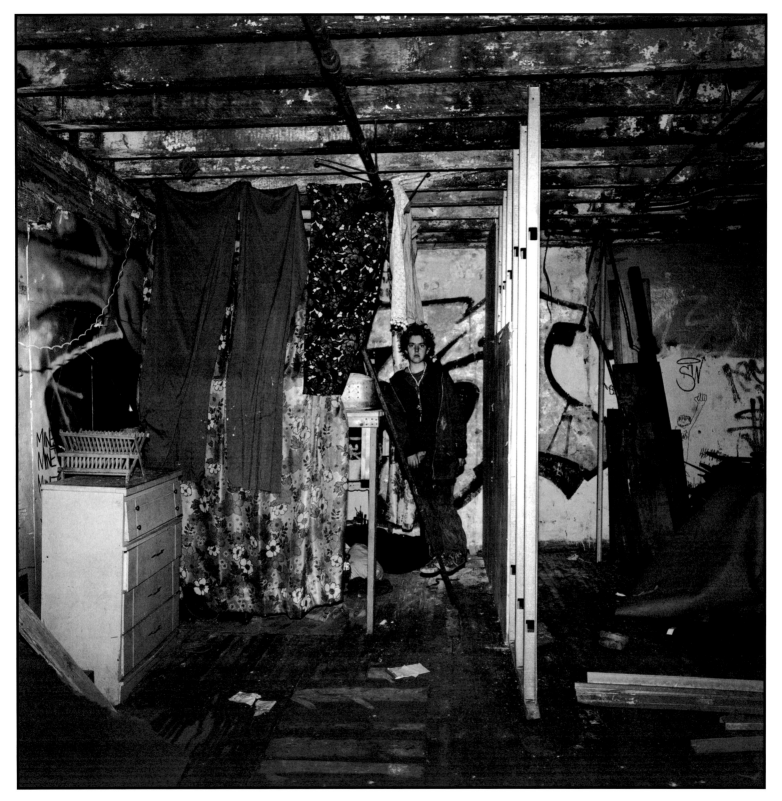

Erica

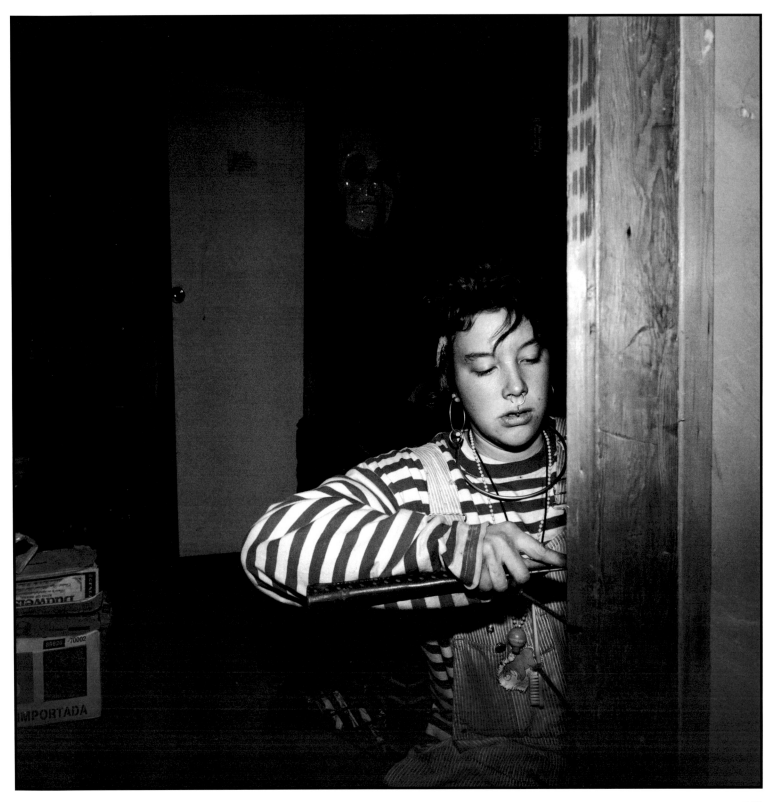

Calli

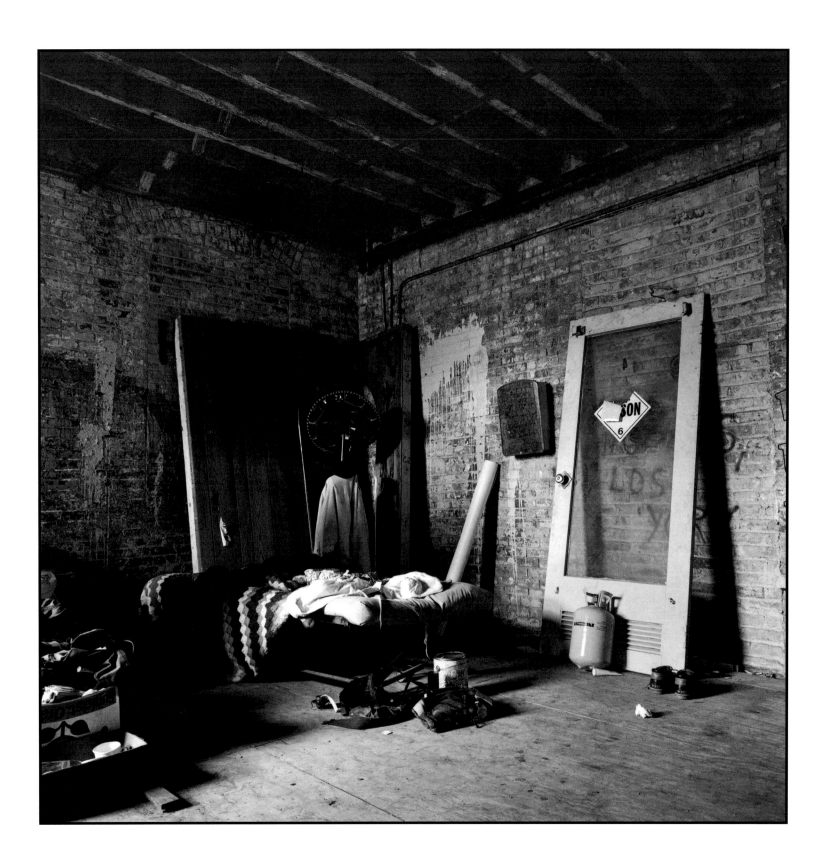

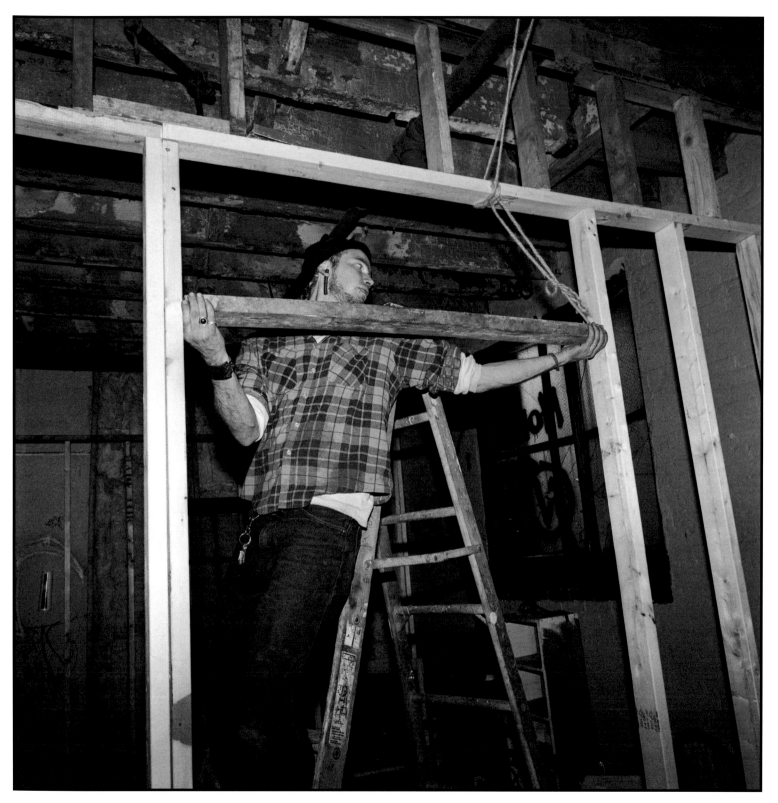

Scott

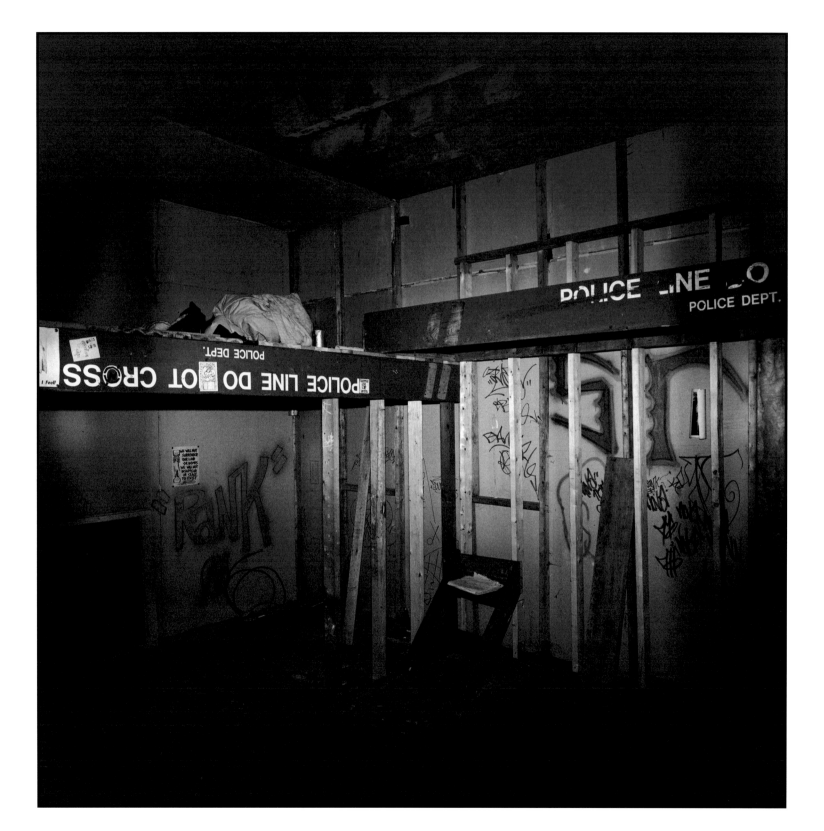

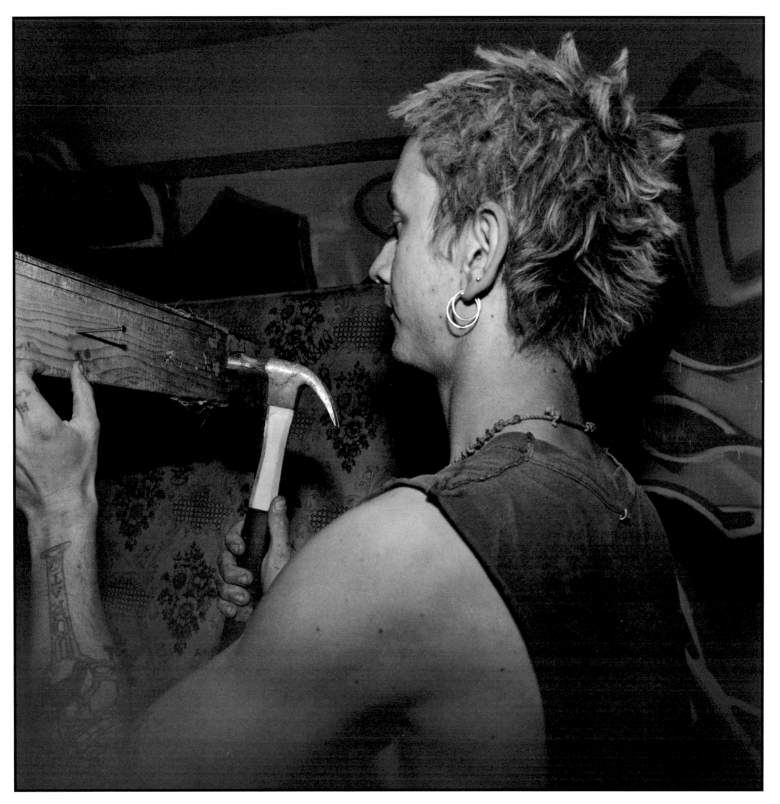

Chad

Maus I did so much work, cleaning out the airshaft, building spaces, everyday chores like getting water and cutting up firewood for the woodstoves.

Lisa If you wanted to live in Glass House, you had to devote yourself to the amount of work that was required, and that's not something you had to do in a lot of other squats. The building was in really bad shape, and one of the conditions for living there was that you had to build your own space. People had put in a lot of time and effort. I haven't seen any degradation of the properties that squatters have been in; I've only seen renovation. I think that Glass House was people taking it upon themselves to do something about all these empty buildings that are just standing there—nobody's using them—and then there's all these people out on the street with no place to live. Glass House was a statement that what was happening, that nobody is allowed to live in this empty housing, is wrong.

Calli It's not something we're paying for with money. We're really putting it together. It's stuff that we find and we hammer and clean and straighten up. You see that this is your house. You're building something. You're building your home. I see the walls not being held together by brick and cement, but being held together by everybody's hands and everybody's hearts.

Donny There was a lot to Glass House. That's why it had so much heart. It was the biggest building squatters had taken over down here in years. I watched people change and grow up there. It was a transforming experience for a lot of people. I saw people come here with no skills, who learned carpentry, who learned plumbing, learned electricity, and learned installing locks, right here. And some of them beat ten-year, five-year drug habits while they did it. Basically, the family mattered more than the building. I mean, we were always working on the building, but we were always working on the community too.

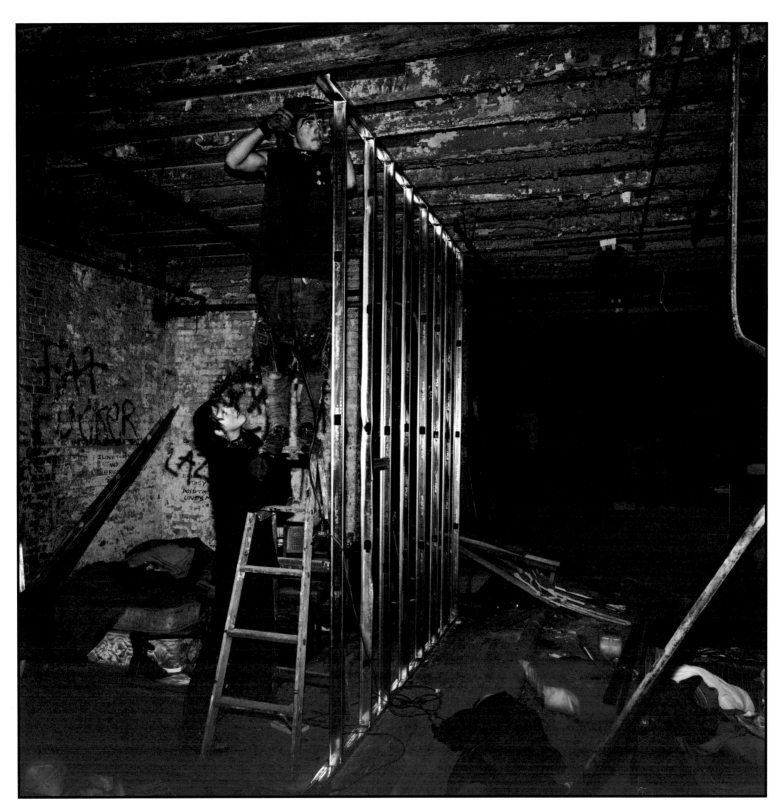

Angela and Markus

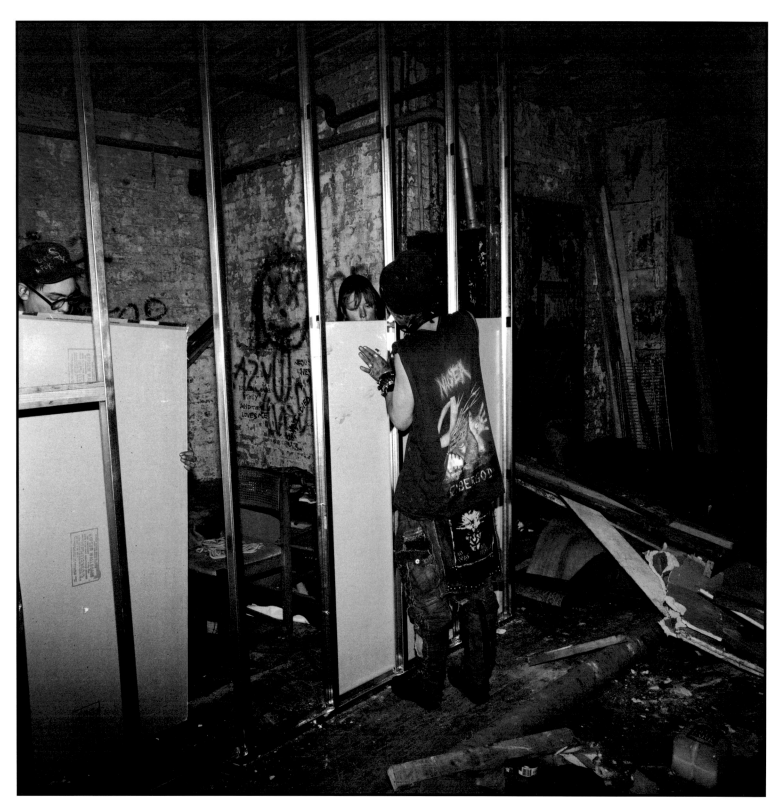

Angela and Markus

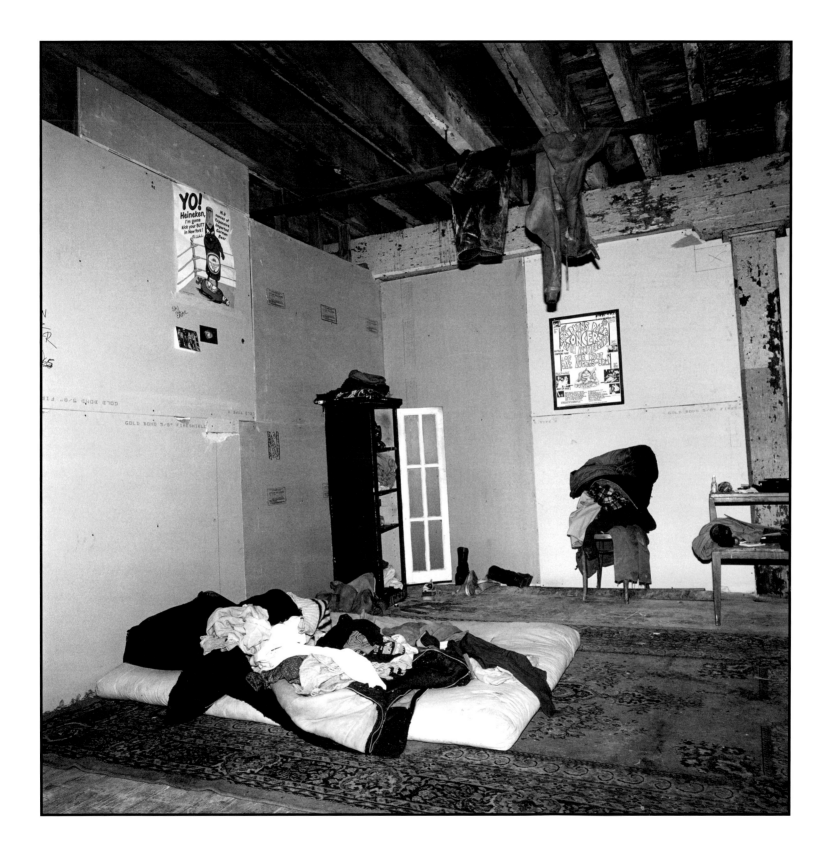

The two-thousand-square-foot community room on the second floor, the first public area to be developed, became the nucleus of Glass House. Residents built a makeshift kitchen around the sink and added a plywood counter, which they decorated with graffiti. The corner street lamp powered a two-burner hot plate and a toaster oven. In the light of a bare bulb clamped to a metal pipe, they prepared meals of spaghetti, rice and beans, or lentil soup and ate on a round metal table they had found discarded along the sidewalk.

Opposite the kitchen, they clustered chairs, a sagging couch, and a low table—all street finds. A small television sat nearby, topped with a radio and a cardboard dispenser filled with condoms. A precarious arrangement of wood planks and cinder blocks held a large assortment of books.

The community room functioned as an informal gathering place where the squatters met casually for meals, to play chess, listen to music, read, sew, or discuss politics. They also assembled there for Sunday night house meetings and Thursday workdays.

Kim After the community room got built, everything got rolling. That first winter, it was like a family. And that's the way it should be, because we had a lot of younger kids who didn't have a family at their own home, so why not come to a home where they could have a family of people who respected them and treated them like equals.

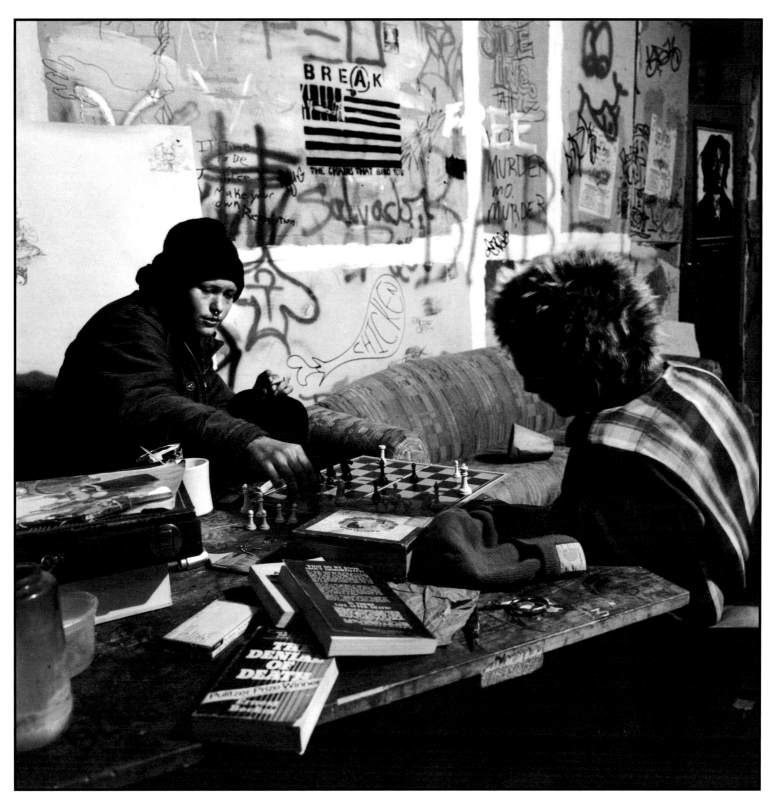

Garth and Chad

DUMPSTER DIVING

"Dumpster diving" was a nocturnal expedition in which squatters raided food discarded by Upper East Side restaurants and grocery stores.

Moses — We were good. We got this guy with a truck turned on to the idea. He would take us twice a week and just take a cut of the food for himself. We would go up First Avenue to the upper Sixties and down Second Avenue. We would go at ten o'clock at night because that's when the stores close and they put out the garbage for the next day.

It was kind of like a SWAT team. The guy would just slow over to the curb and we would all jump out. We would stop at all the grocery stores, Hot & Crusty Bakery, and all the health-food stores. One time we found eight wheels of Brie, totally unopened. We would just go for the trash — tons of fruit and vegetables, milk, butter, cheese, bread, yogurt, ice cream — just thrown out on the street.

If we had a good night and had way more than we could handle, the guy would just drive the truck up to the different squats and we would drop food off. Everybody you went to visit would be eating the same thing for the next week.

Karl — Sometimes when I'm really hungry and broke — dumpsters. There are places uptown that are just teeming with food. There are places that are unreal. During the convention summer, '92, friends went out dumpster diving and they found a bagel shop in the Eighties where they threw out bagels that were still hot, just a little defective. But I like the D'Agostino's on University Place and Gristede's, that's where I usually go. I've literally found whole chickens thrown out. Me and my friend found beer, ice cream, all kinds of things. Pies. Might have a little mold. Cut the mold off, they're still good. Literally kept me from starving. So much food is wasted in this country, it's amazing.

Besides dumpster diving, I look on the street. You might be walking down the street, you see a bag sitting on the side, kick it. If it has weight to it, pick it up, look inside. It could be beer. It could be food. It could also be dog shit. You take the chance.

Toby and Calli and her dog, Generic

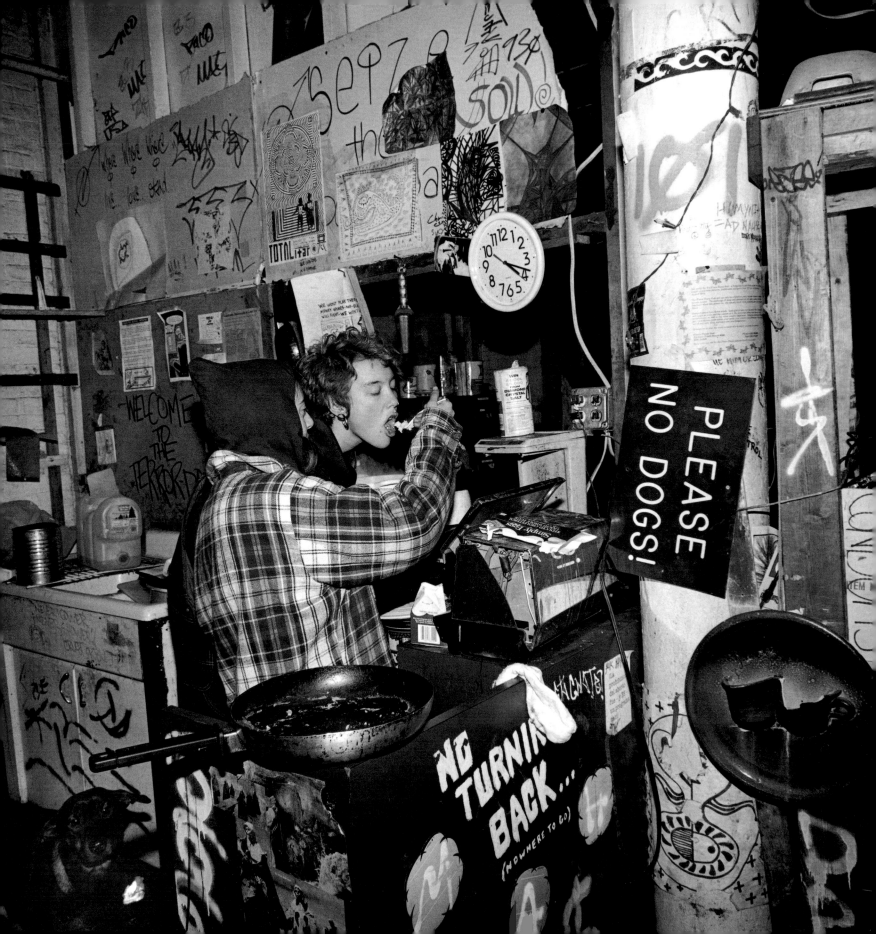

HOUSE RULES

By the time I first visited Glass House in the fall of 1993, twelve women and twenty-six men, most between the ages of seventeen and twenty-one, were living there. The group had established mandatory house meetings and rules for membership and maintaining the building. Membership was by invitation only and requirements were strict. Squatters with carpentry skills commanded respect; they organized and trained workday crews and exerted influence at house meetings. Newcomers literally worked their way into the house.

Toby — Thursday workdays were always really important. You had one month to do four workdays, then they would decide if you could have a space to build. You had another four weeks to do enough work on your space to show that you were making progress, and then they voted whether to give you a key. And I won. I got a key. So then I was a member.

Glass House was more organized than a lot of other houses I've lived in. At other houses, they just called a meeting when they needed one. At Glass House, every Sunday night at nine o'clock, we got together in the community room. It was good, because you got to see who you lived with and really talk about changes and things. Dues were a dollar a week minimum, but you could give however much you wanted, or pay monthly. I'd give them ten dollars here or there, or whatever I had.

Kim always took over at house meetings, wrote the agenda, kept track of attendance, and everything. It just kind of happened. Some people have more of a leadership quality than others. She and Moses were good at finding things that needed to be done and then doing them. I'm sure that was really stressful, trying to take on that whole responsibility.

Moses — We had the idea that, if we could work together as a group, we could live at a better level of subsistence than if we were all separate, so we started having meetings. The rules came about after a lot of discussion at house meetings, and we changed them a few times. The rule of four workdays followed by thirty days to build a space was something that we really wanted to stick to.

Angela — I ran away from home to escape all the rules. There were even more rules at Glass House.

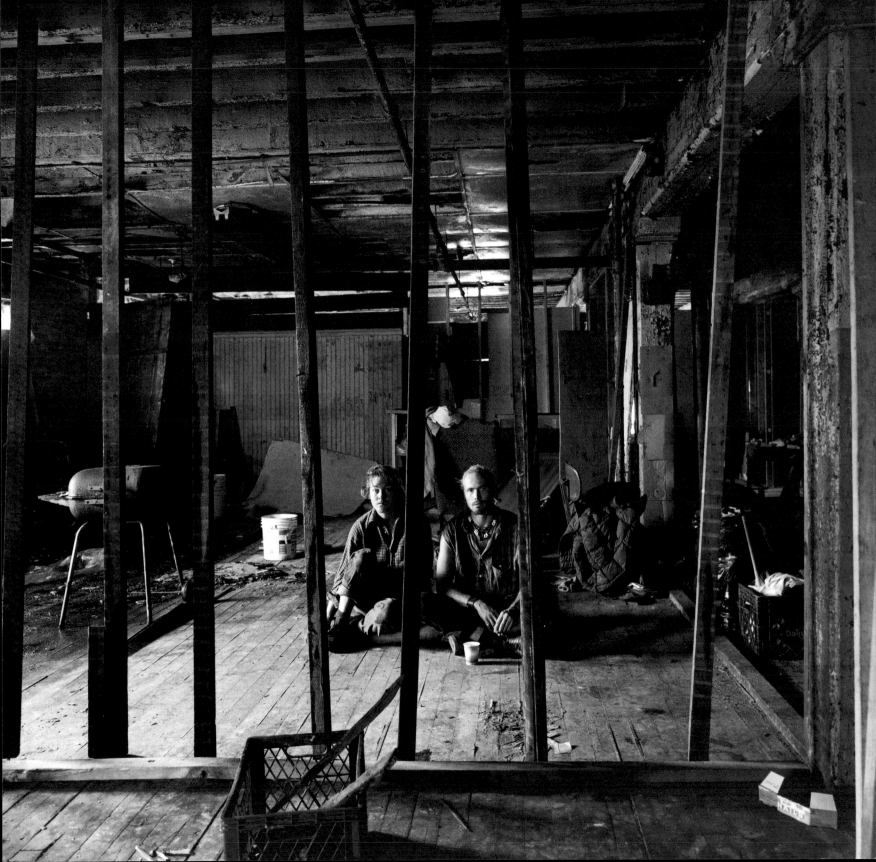

ON WATCH

Protecting the house from police investigation was a major concern of the squatters. At house meetings, they organized four means of security: night watch, bike watch, eviction watch, and barricade crew. Sign-up sheets were posted on the community bulletin board. All members were required to participate on a regular basis. Those on night watch maintained a midnight-to-dawn vigil at the front door. A sign on the community room bulletin board provided them with detailed instructions.

IF YOU ARE ON WATCH AND...

1. THE COPS COME...

 1. Notify those who are in the room to wake people up, call Eviction Watch, and put up barricades.

 2. Do not touch any papers! Ask to see a ranking officer. Be respectful and polite. Have him read any names on the eviction notice. Tell him they do not live here.

2. THE FIRE DEPARTMENT COMES...

 1. Notify those who are in the room to wake people up, call Eviction Watch, and put up barricades.

 2. If they say they need to inspect the building: tell them a lot of people are not home. Ask for a phone number where our lawyer can call to make an appointment.

 3. If they are serving papers: same as #2 above.

3. ANY INSPECTORS COME...

 1. Same . . .

 2. Same as #2 above.

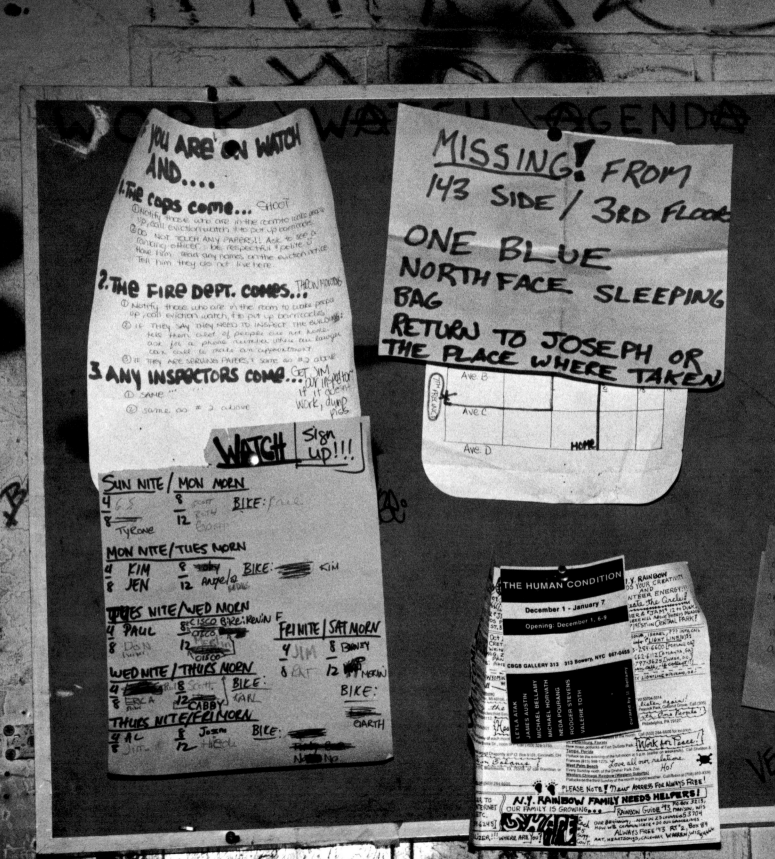

In addition to Night Watch, members were expected to serve on one more security "crew." Bike Watch was a pre-dawn reconnaissance mission to local police precincts and public parks, where police had congregated for previous evictions. The cyclist on duty extended surveillance to other squats as well. Should an eviction be in progress, members of Glass House would go to their aid. Any threatening police activity was immediately reported to the Barricade Crew, which was then responsible for securing the front door and sealing off individual floors. "There are two front doors that are back to back," said Donny. "The inner one is barricaded. There are two more barricaded doors between the rooms on the ground floor and a barricaded stairwell before you can gain access to anything other than the first floor. There are even barricades to seal off each floor."

Eviction Watch was a security cooperative organized by several buildings that agreed to band together to help one another in case of danger. Each squat was responsible for contacting one other nearby squat in a chain designed to alert all participating buildings within ten minutes. Members rehearsed the communication system monthly and occasionally put it to the test.

Moses I had just moved in and was walking back to the building with three friends. Some kid that lived there was standing in front saying, "Don't go in there. The cops are trying to kick the door in." We ran and alerted Eviction Watch and yelled to the other squats. I'd never actually experienced getting Eviction Watch in motion before, and we did it. Within ten minutes there were at least fifty people in front of the door. Everybody got up on the stoop and locked arms, blocking the door. More police started showing up and soon there were ten cop cars. All of a sudden, there was this big standoff. But the people there were really strong. It turned out that the police had been told that a person with a gun was seen entering the building. It was only someone who had been working on the door with a screw gun, but there was a big confrontation until somebody explained it all to the cops. The cops saw that they would have to arrest thirty people to get in, so they just left. That was it. It was a victory. It made me feel really good about the security of Eviction Watch and its ability to work. And it definitely added to my love of the building. At that early point I already felt like I had a stake in it, because I'd been involved in a victory.

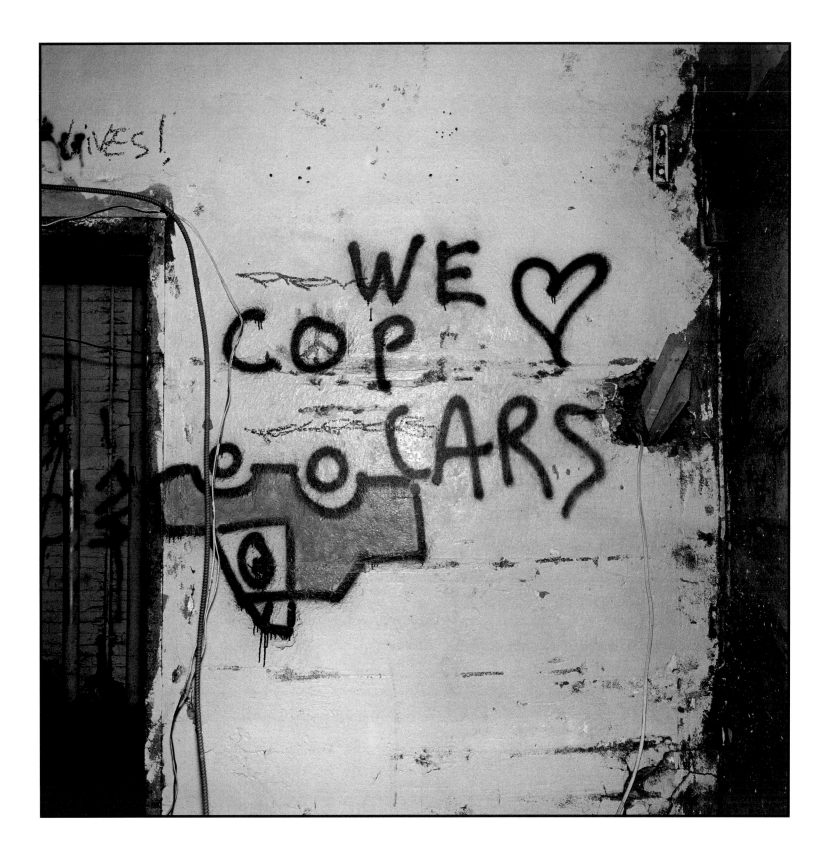

Despite elaborate security precautions, the group decided that, with so many new members, their occupancy of the building could no longer remain secret. At the Sunday night meetings, they voted on rules of conduct and cautioned any members whose activities might attract police attention.

Underage runaways were not allowed to stay, particularly if there was any suspicion that the police might be looking for them. Moses cautioned, "That can bring the heat down on the entire building." Glass House members prohibited panhandling, a favored source of quick cash, within a block of the building; neighbors might complain to police. Angela was surprised to be reprimanded at a Glass House meeting for something that she did at C Squat, but cooperation with neighboring squats was essential to the success of Eviction Watch.

Angela	I drank all the time. I did dust all the time. One night I was sitting outside of C Squat doing dust, when the cops came by and told me to move along. Then one of the guys from C Squat came out and said, "We don't want you coming over here doing drugs and bringing the cops to our door." He must have told people at Glass House, because at Sunday's meeting Kim told me that I'd better not do drugs outside C Squat again.

When a newcomer jumped through a second-floor window, the fire escape broke his fall. Glass House members did not rush him to the emergency room—police might make a follow-up visit—but they kept vigil throughout the night and made arrangements for his safe return to the Midwest.

Toby At first Jay seemed pretty normal, just your average person. He wasn't like a dirty punk rocker. But then he started getting really paranoid.

Erica We found him in the basement, naked, eating asbestos.

Toby Then he crashed through the community room window, because he thought a bucket was a nuclear bomb. I guess he had decided to stop taking his medication. From what I hear, people who do that get this great high and are really happy for a while, then they come crashing down. Everyone had to get together and deal with this. Was it better for him to be back on his medication or go home to his family?

Kim I think he was schizophrenic. For some reason he had decided that Moses and I were the only ones he could trust. He stayed with us in Moses' room all night. We contacted his sister and someone came and got him.

Erica He came back all clean and fancy, got his stuff and left.

Concerns over internal security, personal safety, and private property sometimes caused tensions at Glass House. Some residents felt secure, but others devised elaborate means to protect their living spaces. One member suspended glass chimes across the inside of his door as a warning against intruders. Another member, when he was sleeping or away from Glass House, removed sheets of plywood that spanned the open floorboards in front of his room. Anyone who approached after dark risked falling to the floor below.

At an October house meeting that I attended, Karl asked that a house policy on gun possession be added to the agenda. He reported that on the previous evening he had encountered Linda walking down the hall with a .38 caliber pistol in her hand. Members of the group asked Linda to explain. Unshaken by the question, Linda answered, but was interrupted by the arrival of Christie, with whom she had a strained relationship. After some discussion, the group voted with a show of hands: weapons were allowed in the house, but could not be used to threaten other members.

Linda — Stuff was disappearing from my room. I tried telling Christie to stay out. I even found my large mirror in her room. Finally I had to stick my piece in her face. It was the only way it was ever going to sink in. I don't understand why this is house business. It's between me and her.

Karl — It may be between you and her, but I'm the one who ran into you with a gun in your hand in the middle of the night. I understand your need to make your point, but if that gun goes off, I could get hurt instead.

Christie — I'm not a thief. I woke up in the middle of the night with her gun in my face. My room has to be my sanctuary. It has to be a place where I feel safe. What if I got shot? Someone could just throw my body down the elevator shaft and my parents would never know what happened to me.

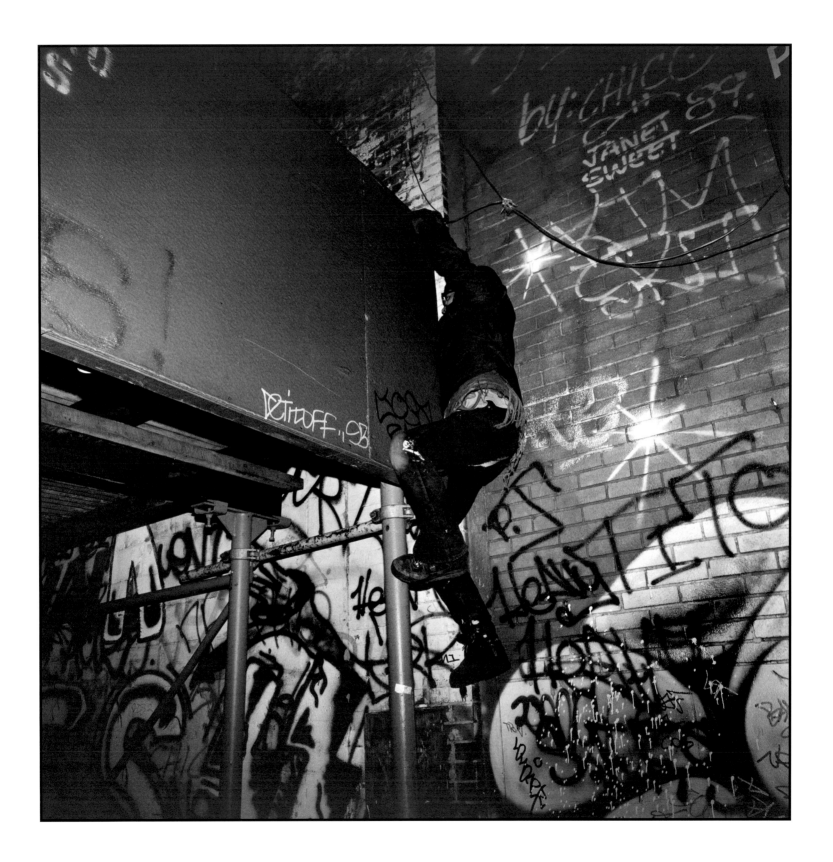

COMMUNAL LIVING

In addition to membership, workdays, and security concerns, at house meetings Glass House residents discussed general building maintenance, household chores, and problems of communal living.

Angela At the Sunday night meeting, the house leaders told us they needed to check us for lice. They didn't want the lice spreading, so they made us all line up and they checked our collars and stuff. I had some lice. I couldn't figure out how I had them because I'd just gotten back from visiting my family in Indiana. I was really irritated, and the member who checked me was a real jerk about it. There's no way to get rid of lice without washing everything, so we ended up getting rid of the couches.

Toby Once two guys on the fifth floor had been drinking and they started wrestling and knocked over a piss bucket. It seeped down to the fourth floor and got all over everybody. Then one of the guys tried to stab Kim with a fork or knife. It had something to do with Gentle Spike's dogs peeing down into the guy's room. He wanted to kill Gentle Spike and all his dogs and puppies.

Maus The guy above us swore someone was stealing stuff from his room, so he put piss buckets above his door. One night he went out and got drunk and forgot. He set off a piss bucket and all this pee came through our ceiling while we were huddled around the woodstove. We all were soaked and everything smelled terrible.

Toby After we got bucket flush toilets, you had to go out to the fire hydrant and bring in a five-gallon bucket of water to flush the toilet. A lot of people would try and get away without doing that and the toilets would clog. It was always brought up at the house meetings.

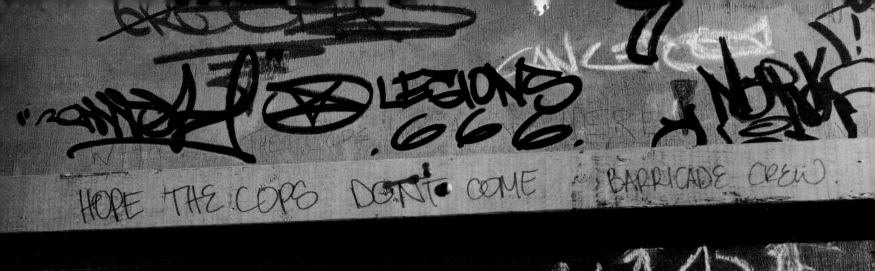

DISPUTES

Donny Most buildings eventually have some problems. It's really hard to find thirty or forty people living together without problems.

Karl If there's an issue that has to be settled, we talk about it. We all vote on it. It's done by consensus. If someone is gonna get chucked out who we don't want, who's screwing up or ripping people off, or is a john, whatever the problem might be, we vote on it and say, "Well, you're out. Now get your stuff, let's go," and we march them to the door. Or, "You've got a week to do better," whatever. It's all done by consensus.

Moses The most important thing to me was to keep a decision-making body in the house that was not controlled by one person, that was controlled by the feelings of the whole group. I really wanted to keep that as consensual as possible. If any one person in the house had a serious disagreement or a problem with something, that was enough to make it an important issue. It was having enough respect for each other that you could be respected by the house. I wanted people to feel that's where you'd go if you had a problem. You wouldn't start some fight, or call the police, or whatever. You would go to the house meeting and say to the house, "Look, I've got a problem," and the house would react.

Kim The forum was there for them to voice their opinion. I just wanted everyone to feel secure enough to state it.

Maus A lot of times younger people exclude older people. But we had Donny and we had Karl. They were just like the parents, and then the kids would fight. It was dysfunctional and it was co-dependent in all those ways, yet I knew we could always talk to each other. I found unconditional love.

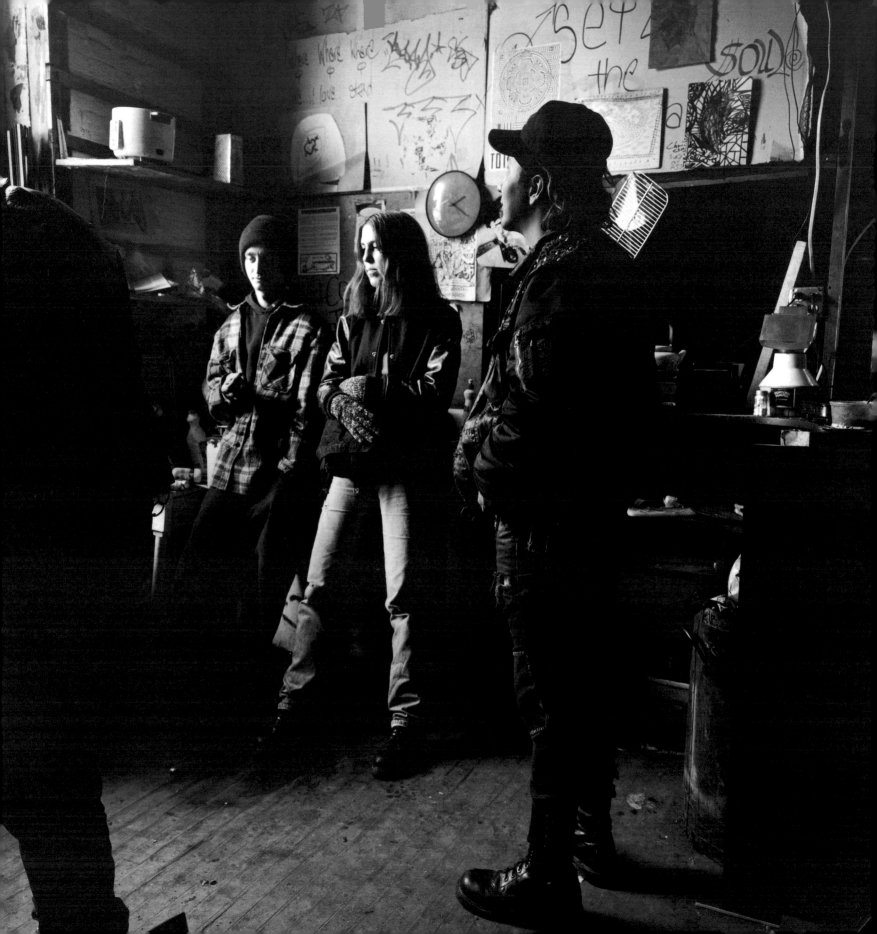

DRUGS

The neighborhood was a center for drug traffic. Dealers openly proffered drugs on Avenue D and surrounding street corners. House members voted to prohibit drug use inside the building; anyone who ignored warnings risked eviction. Drugs were often a heated topic at Sunday night house meetings.

Moses — Squatters get so demonized in the press and by people who live around here, but for a lot of young people, especially urban young people, the two big problems are drugs and violence. At Glass House we did a lot to overcome the drug problem.

Donny — Glass House threw out a couple of junkies, but we also got several people off junk. Because the word is, "Get off or get out." We prefer they get off. And if the people are strong enough to care more about the community than about junk, that's great. If you want, I'll sit up with you all night for a month to get you there.

Calli — I was doing drugs on and off for a while and then over the summer I got really bad again, but they just didn't want me to leave. They wanted me to straighten up. I've fallen down so many times, but I've always been able to get back up because of the people here. If I didn't have so many people backing me up, I wouldn't have stayed, because it was hard enough just trying to kick it.

Kim — Calli had been living here a long time and had already kicked dope once. She had been off for a long time when she relapsed. I knew she could kick it again. I had gotten to know her and I liked her. I knew that she deserved a chance, that we could help her, and that she could do it. With other people, I probably wouldn't have done that. People just coming in, or people who haven't proved themselves to me, I probably wouldn't give a shit about. I would kick them out in a heartbeat. But Calli's a good person, and I know what she's like when she's not doing dope.

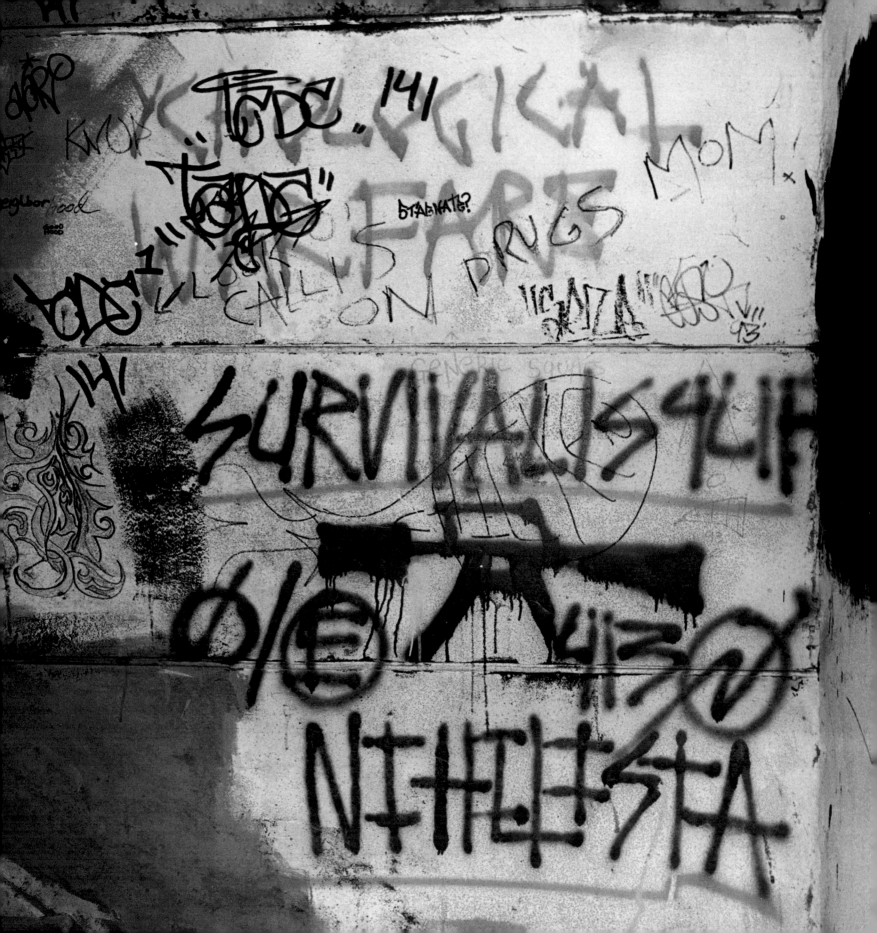

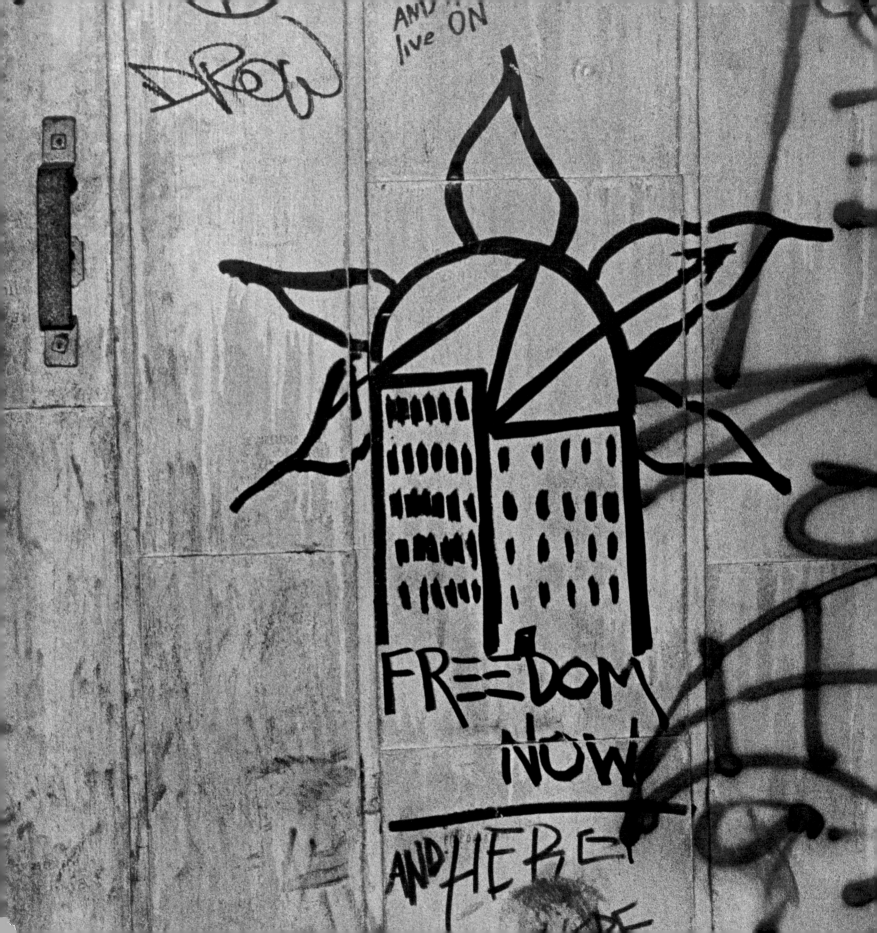

STORIES

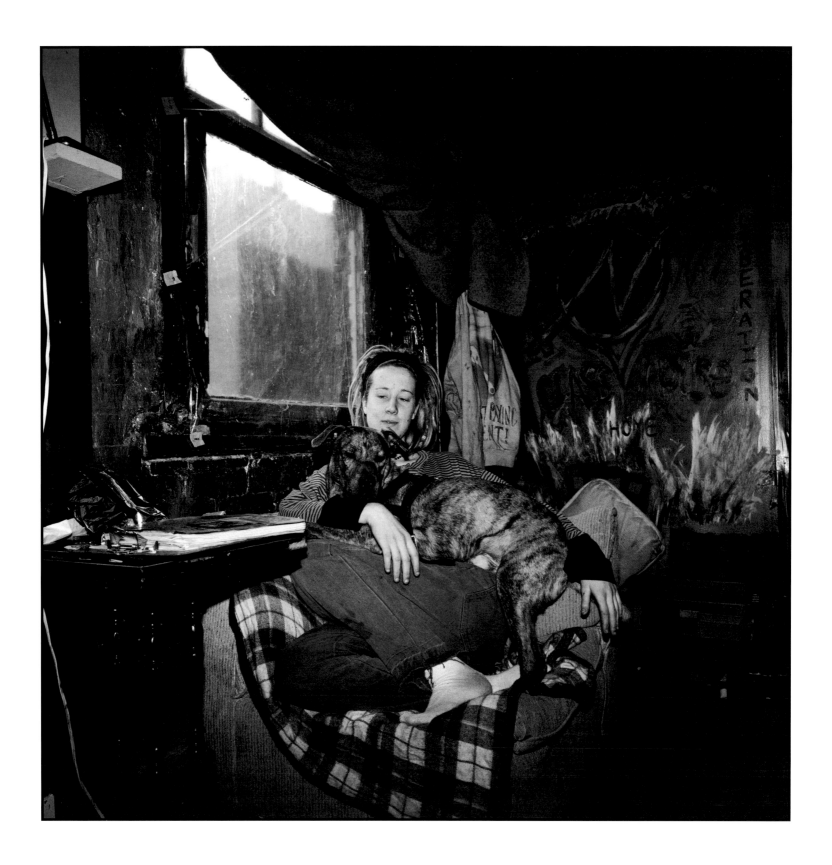

KIM

I dropped out of high school my senior year. I think I just bugged out. I couldn't handle it anymore. I was bored and guess I hated living at home. My parents divorced when I was twelve. I was living with my mother and we weren't getting along at the time. I didn't get along with my father at all. He was a steelworker and a very intimidating person. His whole thing was control. I guess that's why we didn't get along. He wanted to control me, and I wouldn't let him. But living so close to him in New Jersey, I still had to deal with him and I didn't want to. The easiest thing was for me to leave, so I'd lose contact with him altogether. But then I said, "Wait a minute, I'm eighteen. I'm out of here."

I just took off one day. I called my mother on the phone and told her that I was leaving, but she wasn't home to stop me. I had a car, so I piled some shit into it and left. I'd been coming to hang out in Tompkins Square Park since I was sixteen. I'd got to know a bunch of the younger punk rock squatters who always hung out in the park, so this is where I came. I'm not sure if New York was where I wanted to come exactly. It was just the closest and the farthest away at the same time.

I actually came and left the same night and drove to Indiana. That's where Chad was from, so I drove with him. We stayed there for a month, sold the car, took a bus back to New York, stayed for a week, left again, hitchhiked to Louisiana, and stayed there for a month. In New Orleans I was dancing topless in a club. I did it three days and quit. I couldn't handle it. I made a lot of money though, five hundred dollars. It's big business in the French Quarter, but I hated it.

We hitchhiked back to New York, and I lived at Foetus for a month. Then we were on our way to Indianapolis and the car broke down. We took a bus to Phoenix and lived there for four months doing telemarketing. Then we took a bus back to Indiana. I got a job telemarketing and we had a paper route. Then we flew back here.

I got a job in New Jersey and tried to live with my father for three months. It totally didn't work out. He smashed my car with his car, rammed into my car and destroyed it. So I left again and came back here. I actually came back to New York the same day that Foetus burned down. I went to Glass House that night because they were taking in other people from Foetus.

When I moved to Glass House, the outside walls of my room were already there, but they were really bad. I tried to build a bedroom in the corner over by the fire escape, but I didn't know anything about construction, so it was really terrible. I eventually tore it down and built a loft. Broadway Lumber gave us free damaged wood and damaged Sheetrock, stuff they couldn't sell. I redid the wall without taking it down — I added supports. Then I added the couch, carpet, TV, and woodstove. It was really warm when I had the stove going. I painted a mural in anger and frustration when our electricity got cut off. I put flames coming out of the roof and the police at the door.

I tried to get on welfare, but it got messed up, so I didn't get any. For a long time I was just panhandling. I would panhandle on First Avenue and Sixth Street. New Year's and Christmas were amazing. New Year's Eve I made eighty-five dollars and Christmas Eve I made forty dollars. But usually, if I sat there for two or three hours, I could make ten dollars, and that was enough for the day. I would have my dog with me and I would sit outside a store. People would come out with dog food for me, which was cool, because that's really what I was panhandling for— dog food, cat food, food for myself, and beer. That's when I was drinking. I definitely had a drinking problem. It was getting way out of control. I don't drink anymore, though. Alcohol is just as bad as heroin addiction, because you're just as unproductive and sometimes more destructive than a junkie.

One of the guys I knew over at Sixth Street got me a job at the Limelight, but that didn't work out because I really didn't like working in the middle of the night. Then I was babysitting for another squatter, but that didn't work out because I got into a confrontation with her husband after he beat her up one night. Now I've got this bike messenger job, and that's a lot more money.

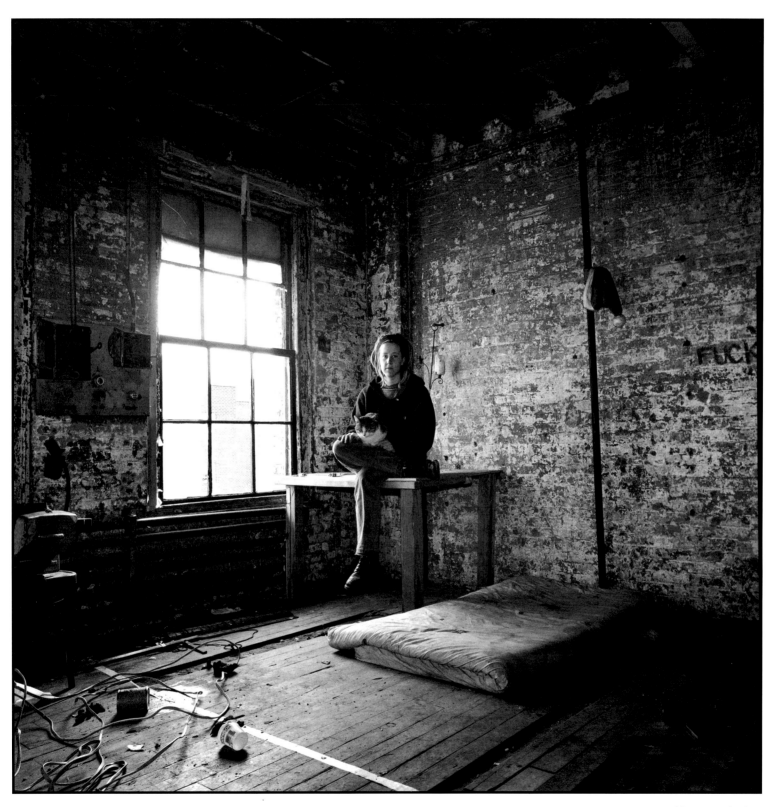

Kim and her cat, Chicken

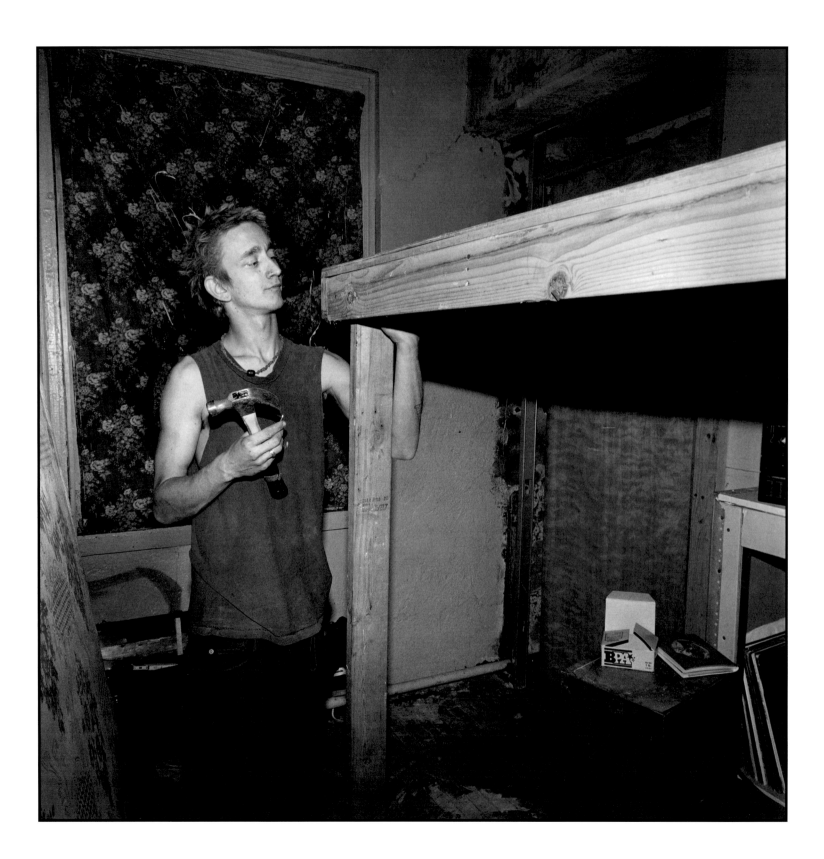

CHAD

I was born in Indiana in 1973. My father was a DJ. He hated to be called a DJ. He wanted to be called a radio personality, a radio air personality. We moved around a lot, to different cities, different towns, different states, all over the Midwest. I lived in Fort Wayne, I lived in Richmond, I lived in Tell City, Cherabusco, New Castle, I lived in Indianapolis, I lived in Lubbock, Texas—not in this order. I lived in Lake Charles, Louisiana. I lived all over the place. I think I lived in Kentucky for a week.

Violence happened in the household, screwed up stuff. I left when I was seventeen. I went through court, juvenile hall, family support center, shit like that. When I was sixteen, I was going to California to get married so I could collect welfare, because it was legal to get married there when you were sixteen. I was going to get married to Kate. She's from Ireland. She came over to America because her father worked for the biggest pharmaceutical company, Eli Lilly, which pretty much owns Indianapolis, because they have a big factory there. Anyway, it was Kate and her twin sister, Claire, Steve, me, this guy Ricon, and Billy Provis Trash, all three was his name. He's dead now. He's the only reason why we wrecked anyway. He took a bunch of pills. I was sleeping in the van that we'd stole with Steve. It was his parents' van. We wrecked in Missouri, skidded across a four-lane highway. I went flying out the back window. Helicopter came to pick me up. I almost died. I've got three metal plates to hold my jaw together. I've got two on the right and one on the left. I had a lot of temporary memory loss. I remember going into high school one time and I didn't know where I was, so I turned around and ran away, freaked out.

I went to three different high schools, two in the same city—one on the west side, one on the east side of Indianapolis. They were rough schools and they were pretty bad, gang-ridden. But I was a punk rocker, me and three or four other guys, so we were pretty cool. They left us alone. Then I ended up going to the east side. We had to go through metal detectors to get inside because there were killings, lots of violence.

I never graduated ninth grade, and I was in ninth grade for a couple of years, I think, because we were always transferred to different public schools, different credits. I don't remember what the deal was. I dropped out, got a job, worked with my mother at Kmart at the time. She worked at Kmart for years, then did work with the mentally ill. Now she monitors kids at a correctional facility and really helps these kids out. My mother's really, really cool.

My grandmother didn't have any money. She lived in this place in Indiana called Hospital Heights. It's the area next to the hospital where the poor lived, shanties and barrel fires, the whole bit. My mother drove me down there four years ago and showed me. It wasn't as bad as it used to be, she said. But it was still pretty messed up.

I finally left Indiana for good and went to California with some friends. I didn't even know about squatting when I left Indiana, I just wanted to get out. I found out about squatting in San Francisco—Fifth and Shipley was one of the squats I stayed in. In Santa Cruz, after the earthquake, I stayed in the damaged buildings. Hopped some freight trains out of there finally. Stayed in a shelter in San Francisco that a lot of squatters from New York stayed in. It was called Larkin Street Project.

Then I went up north—Oregon, Klamath Falls. I got arrested for hopping freight trains, got back on the train, got to Portland. I was in Portland during the John Metzker trials, those Nazi skinheads who killed a black man. It was hard to get out of the Portland Yard because all the skinhead Nazis from the U.S. were flocking there. I was punk rock at the time and I had to dress down to get by. Bones, the guy I was traveling with, called his grandparents and got money, but I was stuck there. I went to churches and tried to get travel vouchers and stuff to get out. I ended up having to call my parole officer. I was a juvenile at the time, so I got a free ride on the Greyhound bus.

I went back to Indiana, escaped from that crap, then I went up to Madison, Wisconsin, to deal with Kate, my girlfriend, who had ended up getting pregnant with this other guy. That's a whole other story. I broke up with her, then finally I made it to New York.

This was the end of '90, beginning of '91. I had heard about Tompkins Square Park through my friends. It's like a circuit, the punk rock squatters, traveling. I found out that the only place in the United States to really be a squatter is New York.

I hooked up with this hippie guy on the New York bus. He was from Madison. He wanted to take me to Times Square and show me places to sleep on some grates, where the air was warm.

We made it to Tompkins Square Park. I saw all these tents up, all these people. I was looking for the punk rockers hanging around the barrel fires. That's when I first met this guy named Army. He took a two-by-four across somebody's head because they were having an argument. So I went straight over and hung out with him. He knew my friend from Indiana that I was supposed to meet up with, Bones. I was known as "Rat." I didn't change my name to Rat, friends changed my name when I was fourteen years old. A friend had a pet rat and it jumped on my shoulder and hung out with me, so everyone started calling me Rat. Plus they said I looked like a rat, I was so skinny and wiry.

There were a lot of Vietnam vets in the park at the time. I hung out with the vets and the displaced Native Americans. It was a totally different scene then, not a lot of white people. You didn't see them on Avenue B, halfway through the park you didn't see them. Guys would have fights. One time they asked me and my friend to grab a shotgun out of one guy's tent and then carry it over to this other guy's tent. It was like that in the park. It was a completely different world. There were marches and protests. Things were a lot more violent than they are today.

Tompkins Square Park's got a history that goes back to the 1800s. It's always been the point in New York City for all of the dissidents. There were speak-outs all the time. Every Friday, it was the place where people who lived on the Lower East Side could come and literally speak on a soapbox and talk about the shit that they were going through—rent, landlords, black males, HIV, jobless, that kind of turmoil, hell-type shit. And then we would get roused and we'd go out and protest what needed to be protested in the neighborhood. The cops always came and tried to tear it up. We had little mini-riots before the big one in '91. Cops were always coming, the firemen more. So that's why the riots happened. It wasn't just pointless rage. It was rage that was definitely geared toward the repression that was happening with plans like spatial deconcentration. I was new to this. I was a kid, and this is what I was hearing.

So I was living in Tompkins Square Park, staying outside, in a tent sometimes, next to a barrel fire all the time. We'd start a barrel fire, the fire department would come and put it out, we'd start another one and they'd put that one out. Me and Bones opened up three or four different places trying to move everyone out of the park, but it didn't last very long because of the cops. We'd go to a squat called Umbrella House and borrow bolt cutters and we'd pop locks. I spent a lot of cold winters with a lot of people when we had no electricity and no heat in the buildings. I ended up moving to 3BC. It was 3BC because it was on Third, between B and C. It was the ass-out building, rats crawling across your stomach when you sleep, stuff like that. It was just a total war zone. But then I tried to stay at Foetus for a little bit with my friend John. Foetus squat was a good one. It was on Ninth between C and D. Then I stayed in C Squat, then Glass House, then Sixth Street. I lost a lot of stuff in these buildings, too. The cops would just hole up your shit and not give it back to you. Now everything's in the courts, so hopefully we have a chance. Now at least we have rights.

I was always in and out of the city, traveling around. I hitchhiked to New Orleans with Kim. I hitchhiked and hopped freight trains and got rides with truckers to different parts of the country. I lived in Minneapolis a couple times. I was always going somewhere. I would visit colleges, universities.

When I went back to Indiana with Kim, I went to school. Since I'd never graduated, I got my G.E.D. Then I went to Ivy Tech and took general maintenance classes, studied carpentry, masonry, plumbing, electric, and I took it back to New York so I could squat and do it proper.

When I came back to New York, I ended up in Glass House. Glass House wasn't exclusive like the other squats. They didn't care if you were from the Midwest. Glass House was different because the energy there was very young. The only thing that ever seemed to get done was by us, the young kids. And the way we went about doing things—like this guy Cheese. I moved into his room before I built my own room, and he'd built his whole wall out of trash. He didn't even use studs or Sheetrock, nothing. He had car parts and doors and windows for walls. Radios and typewriters made a wall. It was pretty funny. It was the energy. Every day was an adventure.

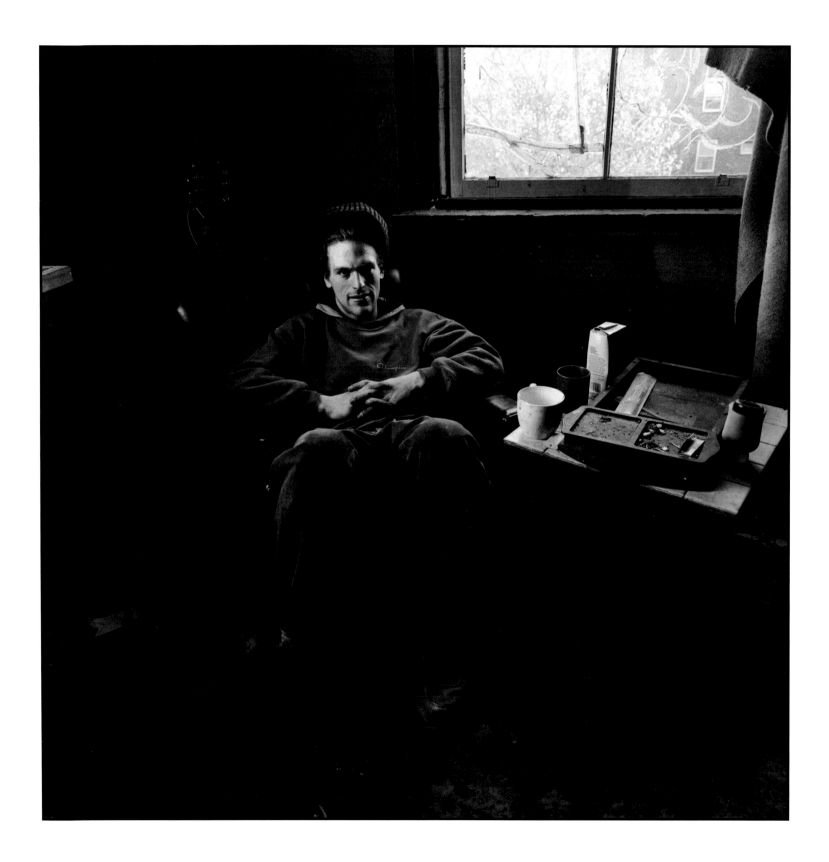

MOSES

I'm from New York. I grew up in a small town upstate, near Albany. I finished high school, barely. I was sent to a prestigious private boarding school in Massachusetts because I got good grades, but mostly because I got bored and was getting into trouble in public school. Boarding school was an uncaring, cold environment, with a lack of support from teachers. All they cared about was what college they could get you into, and that was becoming less and less important to me as I got older. At the same time, this group of friends that I had grown up with had become a tighter group. I was only seeing them on vacations and during summers, but we became tighter and tighter. It had to do with the fact that we were experimenting with drugs and a changed consciousness, but most of all it was this sense of community that I never got at school. At school it felt like all the other kids would bite me in the back if they got a chance. They were just waiting. With these people, I was in a circle of friends where my relationship to each one was just as strong as the other. That was my first experience of a communal feeling. A few months before graduation I got kicked out of boarding school for breaking curfew, after going there for two and a half years. It was actually because my friends came up and visited me. So I went back and graduated from public school. I never did get the diploma, because as soon as school ended I was gone.

A bunch of my friends came to New York with me, and we met people here. We squatted for a while, but not really well. We didn't have our own space and it was really rough. It wasn't the right thing at the time. It didn't trigger much motivation in me. That was it. I split from all my friends and left, alone. It must have been the fall of '91. I got a one-way ticket to the Virgin Islands.

I didn't know anybody in St. Thomas at all, never been there, just got a one-way ticket with only seventeen dollars in my pocket. My theory was that I could go anywhere and survive. That was what I wanted to test. I used to call myself an experience junkie. I didn't care whether anything that happened to me was good or bad, I just wanted it to be different. For a long time I did nothing for money. I just lived without it.

I lived with a Rasta on a boat for a while. He had this scam he used me in sometimes. There was a lot of crack and a lot of white crack heads in the area, but nobody white could buy crack. You had to be black. So people would come up to me and him, because we were a white guy and a black guy together, and they would think it was safe. So they'd give him twenty bucks and he'd give them a five-dollar piece of crack. He'd take the other fifteen and we'd eat with that. I also had a job playing music in a small club for a while, mostly just surviving. And I lived with this woman and helped her get over her addiction. She was really, really depressed.

Then I came back to the States, but I didn't go back to New York. I went to the West Coast, traveled, and had some really horrible experiences there. It was about a year and a half before I came to New York. And that was the day that Foetus burned and the day that I moved into Glass House. By that time, I had been homeless for so long, traveling for so long, just living out of a bag for so long, that I really wanted a home to stay in. And there was Glass House, this incredible building. I was awed by the building the first time I saw it. So that was pretty much it. I was off and running. I started building a space.

But I started with no skills. I went from having no knowledge at all to being the one who people would come to and ask questions about the technical work. That was a big thing for me. The two most important things about Glass House were the actual work and the learning involved in that, in gaining skills and using them to make it a better place. I saw myself as having an important role in that.

I didn't start out with any advantage at all. Anybody could have done it. The only thing that gave me sort of a position was that I'd been here for so long and been devoted to it for so long. I was skilled in building, but more than that, I knew every inch of every floor of Glass House. I had been through the building and worked in it so much that I knew where everything was, how everything ran. Me and Kim understood the electricity from bottom up. We understood the plumbing, what was there and what was going to be there. We'd been there long enough not only to know everything, but also to form a vision of how it would be.

When I first got there, my room didn't even have any walls in place. It was just an empty corner. There was nothing there. I had some friends who gave me a tape measure and a handsaw to use so I could start building a wall frame. It was the first wall frame I had ever built, so it was very crooked. The bedroom was an experiment, but the living room, that was my masterpiece. Everything was perfect, or close. They were all tight corners. That room was nothing without me. Every screw, every nail, had been put in by me. When I came home at night and sat down, just knowing that gave me a comfort that I could never get in a place that I'd rented. I always knew that there was a chance that the police could take it away, but it still seemed one hundred percent mine because we really had full responsibility.

People try to say that squatters are not responsible, or squatters are lazy, but it's not that. If you work and pay rent, you don't have to worry. You call someone up if something goes wrong and they have to fix it. If you don't pay rent, there's no one you can call. When the toilet's backed up, there's no one else to go to and get a plunger but yourself. That's the trade-off.

I feel so much older than people who went to college. I really feel that I learned a lot more being in the real world and learning things for myself than being in the protected environment of school. I'm sure that my parents probably had mixed feelings, they had expectations. But when I would explain to them, "Look, I have to figure this out for myself," they would understand that I couldn't take anyone's word for it. I know politicians try to portray that we're just kids slumming it for the glory of living in the streets, but everything I have I've done myself. I'm twenty, almost twenty-one. I don't know too many kids my age who have made a full life for themselves, or could.

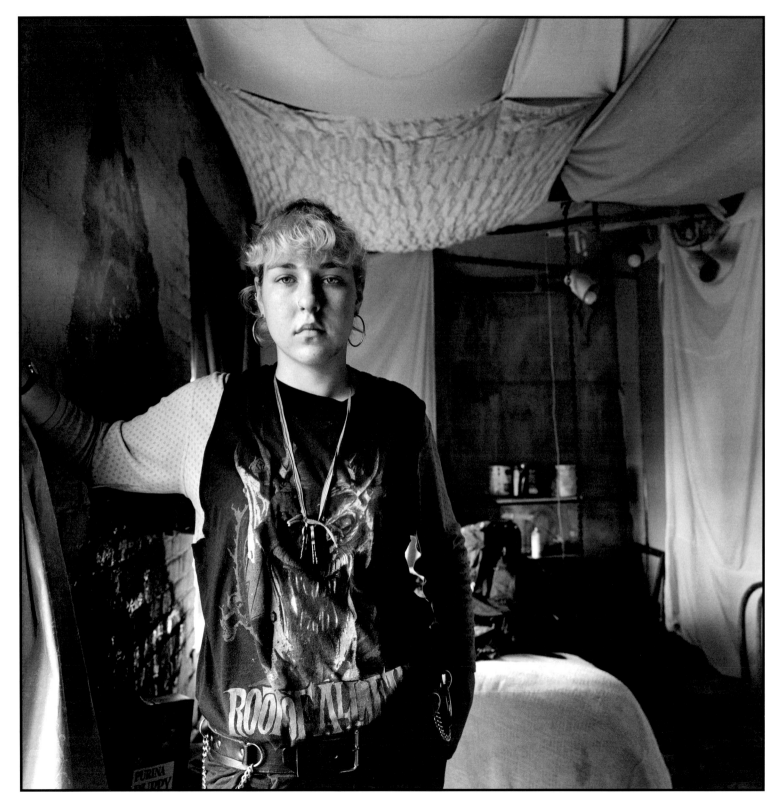

Lisa

LISA

I've got this ring in my mouth. I take it out when I go to the club because it looks more feminine. I feel superficial because I put on makeup, which I don't usually wear, I add a butt-length wig, and I take out my piercings. This girl Lee, she's like, "You come in and you look homeless and then you turn into a beautiful angel. But look at your shoes. You look homeless." Okay, I look homeless. That's fine. I feel comfortable that way. I'm just totally different when I'm there.

I grew up in Ohio. My family had always been on a very tight budget. When I was finishing high school, it got worse and worse. It got to the point where I felt like a burden. And I had some personal problems with my father. After high school, I moved to Cincinnati, got my own apartment, and lived there with a couple of friends. That ended and, because of the situation at home, I couldn't live there.

I met Spaz when he hitchhiked to Cincinnati to visit some people. He got stranded down there, and I was like, "Hey, Spaz, let's go to New York." He was like, "Let's go, we'll leave Friday." And we did. We hitchhiked.

The first place I came to in New York was Avenue A because Spaz told me, "That's where all the punks hang out, so that's where you'll meet people who'll hook you up." Spaz lives on the street on Avenue A. He's homeless and he's a junkie. When we got to New York, he went and did his own dope, and I didn't see him for the rest of the day and the rest of the week. The night I got here, I met a guy named Teeth, who lives on Avenue A, and I met this girl named Leah. Leah was short and skinny and she had freckles and bright red hair. She had a septum ring, and a nose ring, and she was wearing these little blue glasses. She was the first girl I hung out with here. We drank beer together. Leah was hanging around with these two guys, Skip and Doom. Then Leah went off with them and I didn't see them for six months. I just saw them that first night.

I met big black Sean. He stays at Tompkins Square Park a lot, but he was staying in Doom's space. Sean took me and two other people to Glass House. We all three stayed there for about a week. It was a lot of fun. Sean was hitting on me all week, "Oh, cute girlie, just got into town, huh?" I was eighteen. I was about fifteen pounds heavier and I had acne. I had a short blonde Mohawk and wore a Greek fisherman's hat all the time. I always wore lots of eyeliner and bright red lipstick. And I'd just had my nosed pierced. I only had one set of clothes—gray thermals that were dyed blue, nylons on top of them because that was really warm, a pair of cotton tights to put on top, a blue and green plaid skirt, my combat boots, and an Exploited shirt with the sleeves cut off that I got at a concert in Cincinnati. It rotted off my body squatting, took like two months.

My first two or three weeks here were the longest. It was very hard because it was cold and I didn't have a space. I was the guest of somebody who was watching somebody else's space, so who in turn was a guest and didn't have a space. I saw what squatting and Glass House was about, and I really liked the idea. I liked the things people as a group were doing with the building. At that point Glass House had accomplished a lot.

Glass House was very, very with it. They had their own pecking order set. Pretty much everybody got along. There were some older people who took up space and didn't contribute much, but it wasn't the majority at all. It was just a very good place to be at that time. The first couple of days I just fell in love with the whole idea and I stayed and stayed and said, "I don't want to leave."

I got into an argument with a cop on Avenue A on the first of July. It was about midnight. The cop said I was a disgusting dirty squatter, and I said she was a fucking pig. She didn't like that, so she arrested me. No, I think I went up to her and called her a pig. I'm not saying that I was absolutely in the right. I got arrested and sat three days in jail. They had me on all these bogus charges. The only thing they made stick was disorderly conduct. I did three days of community service in Tompkins Square Park and that was it. It was grueling. It's all over. I don't even have a record. After a year it's sealed. I don't drink so much anymore because I haven't been able to control myself. I get into arguments and fights. But I've never had any problem quitting when I need to, like if I need to work or something.

I need to go beyond squatting. It seemed a very big accomplishment to fit into that kind of system and be part of that project. But now the novelty has worn off. I think I need to do something more. It was necessary, I did it, I'm doing it, and now I'm done with it. Now it's time for me to move on.

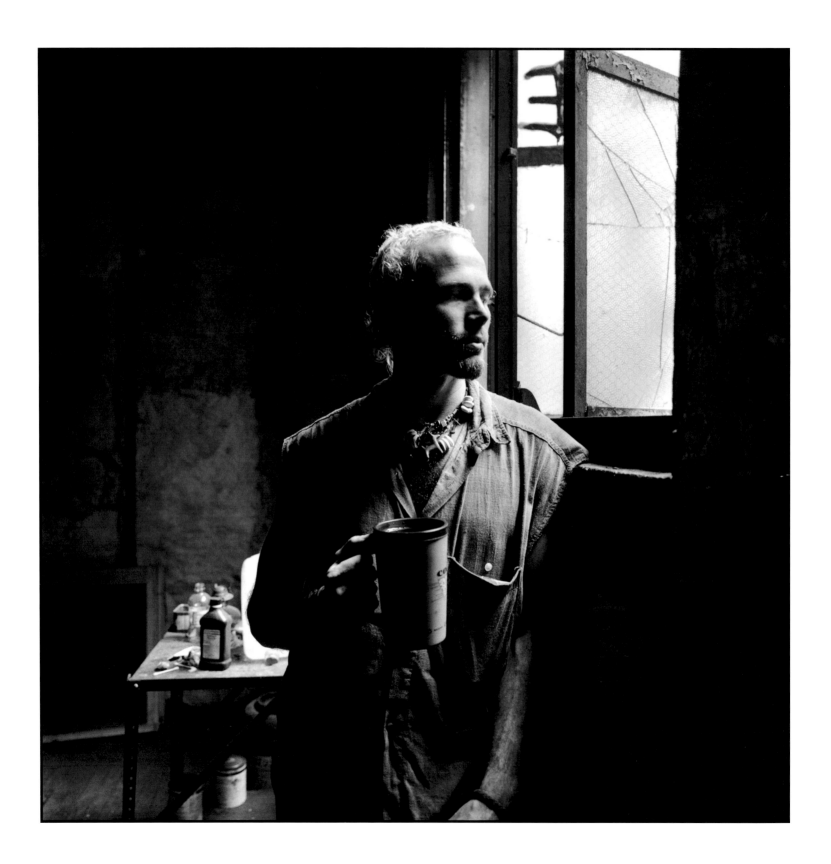

SCOTT

I came to New York because I was tired of living in Ohio. I was tired of living in other people's houses, tired of living in my car, tired of living outside. So I decided to come to New York and try living here, not knowing where I would end up. I was always some kind of a freak and a misfit, a fat little faggot. Maybe unhappy, but at the same time I wasn't concerned with too much that was going on around me. I wasn't really concerned with other kids too much. I wasn't concerned with my relatives too much. I guess that maybe I just never bonded with my entire family.

I was an adopted kid. Maybe there's a process that you have to go through to bond or something, and it just never happened to me. My parents are just traditional workers. My dad was in a factory and moved on to become an executive, basically came through the sixties and boom. They were just very conservative, very traditional people who came from very traditional families—very boring people. The lifestyle they choose to lead just doesn't seem to allow any room for personal freedom, and I've always been into personal freedom all my life. So when it came time to settle down or move on, I moved on. Their lives don't really have room for me. So I said, okay, I'll move off, because I can't fit here.

I finished high school in Dayton, Ohio, but I didn't have a lot of friends there. People would be my friends and then they wouldn't be my friends. They would start off artists and then they would be going off to business college, or whatever. No one's got the creativity to just branch out and try something that is not a part of the reality. I never got too far with college, then I ran a magazine shop—sales, keeping track of stock. But it just wasn't anything that I wanted to do for the rest of my life. I wanted to get out in the world, do more things. Of course, when I was growing up, I didn't think I was going to be living in abandoned buildings and bathing once a week—if I'm lucky.

I had heard that there were squats in New York, and that people were able to do a lot of things without the whole specter of having to pay monthly rent and hold down a continuous job. You were given time to develop any interests or skills you chose, along with a bunch of people who have chosen to live in a way that is slightly outside the mainstream.

I came with a friend, but he didn't end up staying around too long. I decided to stay at all costs, ended up selling my car and staying. I moved into Foetus squat almost as soon as I got here. This girl who lived at Foetus had come through Dayton. She had stayed with friends of mine in a place where I was living at the time, and she was talking about what you could do in the squats in New York. It sounded really interesting to me. I'd made plans to go traveling across the country, but that was kind of falling through, so I said, "Well, hell, I'll go to New York." No one knew I was coming. I just showed up at Foetus one day. The girl didn't seem too happy to see me, but it was winter, so I think that she felt obligated to take an extra person in.

When I first came to New York, I wasn't really known by a lot people, so they kind of looked at me suspiciously. I was basically known to be kind of a violent drunk, so they were kind of watching me. This scar was some beautification I tried on myself some years ago. Usually when I drink it shows up more. It was a fad, an equal sign with a slash mark through it, a "not-equal" sign. I started out burning it in with a fork, but the burn wasn't very intense, so I went over it with a butter knife and made the lines longer and put the bar through it. I did it four years ago. I just didn't know what I was doing at that point. I have an old I.D. picture of it when it was very prominent, fucking crusty and everything. I got arrested shortly after I did it, too, and I was in jail with this big old burned scar on my face. Everybody thought I was the freakiest thing they'd ever seen. They were just totally scared of me.

When I got to Foetus, I was given a room on the ground floor, which was supposed to become the library. But there was pretty much no roof on the building, so the first rainstorm came along and everything my friend and I had got totally soaked. I was definitely looking for other places to live in the building. At that time, not that many were living at Foetus. I'd say it was almost ten people. No one was living above the second floor, because we had to use a ladder and a rope. So we just started building our own wooden stairs out of the old standby, police barricades. I tried one place on the second floor, but then someone else said they wanted to live there. I tried staying in the back of the building, but someone else was going to be living there too.

So one day, out of desperation, I just climbed up the metal studs—there were no stairs—to the fourth floor. It was pitch black and I couldn't see anything. So I said, "Well okay, whatever it looks like in the morning, that's where I'm going to be living," and I went to sleep. I kept hearing pigeons all night. I woke up on a pile of rubble. This place that I had found was the driest, so I just started living in a corner on the fourth floor.

After I'd been there a little more than a month or two, people would ask me if I wanted to become a member of the building. I was saying, "Well, I don't know if I want to take on the responsibility of being a member and shit, and have to sit through these meetings all the time and have these things expected of me. I'm glad just to work here." But then I just said, "What the hell," and I became a member.

As time went by, I got into the whole scheme of things that were going on around there, did a lot of work projects, cleared a lot of rubble, took my own space. I didn't know anything. I barely even knew a screw from a nail. I'd go around and see other people doing their spaces and kind of pick it up here and there. No one really knew what they were doing. Basically, we all kind of happened on it by luck.

I don't think that I really started learning anything about building until after we were burned out of Foetus and we had to start learning how to do things, so people would take us halfway seriously. I moved into another building up Ninth Street after that, Serenity squat. I lived at C Squat all summer and we built the roof.

I moved into Glass House a couple months ago. Since I've lived here, I've worked on the parapet on the north side. The city felt it was a big threat to the public, so we went up there and we fixed it. I'm putting off doing any more major building projects until I get enough of my space livable, so I can have a place to stay. I'm staying in someone else's space right now. When they come back, I want to be out of there, be in my own space. I'll probably have it livable in here within a week.

To be part of the squatting community has meant an entire change in my life. I couldn't drive a damn nail before I came to New York. I learned by doing, by coming to workdays, by working on the roof, building windows, building stairs. You work with someone who's done it before and you pick up on it. At Glass House, I could start from scratch and build things that weren't there. I feel good about the work I've done on that space. It's given me a lot of self-esteem. It's given me pride that I didn't have before. I still continue to have it—that's something.

What I haven't seen in any of the other squats is that Glass House would take people who were not wanted by other buildings. They would give housing to people who could not have gotten into another squat. For me, that was the most attractive thing about Glass House as an entity. At Glass House, if someone was sleeping on the sidewalk, we took them in.

MERLIN

I lived on the street for seven years. Sarah came by and said, "You can't be out here. I refuse to allow it." She picked me up and carried my butt into this house. I went to my first house meeting that week and everybody in the place said, "Okay, this is your space now." I became a house member immediately. I was the last person to become a house member without having to go through four meetings and four workdays and all that. I've lived here since. I knew Sarah and she would pass by me all the time and say hello, but to have somebody come out of nowhere and say, "We're taking you in." Hey, my birth family doesn't do that. I would die for these people. They're my family. I can't say any more than that.

The major problem with "squatting on the street," as I call it, is not so much the weather. You can pile extra blankets on, you can stay fairly warm. It's not having a door that you can close and tell people, "No, you can't come in." If you want to be alone sometimes, you can't. You just can't get away from people. That was the major thing Glass House did for me. It gave me a space to write and time to do it in. I could just go in, close my door. Sometimes I would be in the house and wouldn't come out of my room for three days and no one would even know I was there. "Where'd Merlin go?" "I don't know. He's out somewhere." And then I'd come out of my room and they'd go, "When did you get back?" "Back from where? I've been here all along."

I didn't adopt the name Merlin. It was given to me. I can't do it anymore, but I used to practice close-up magic, sleight of hand—card tricks, coin tricks, things like that. That and the fact that I used to keep my beard trimmed to a point and my mustache waxed up. Friends would say, "You look like Merlin, man," and it stuck. My real name is Paul Hogan.

The first time I came to New York, I was six. We came from England. Then I ended up in Levittown, Pennsylvania. I ran away from home at the age of ten and I came here. Interesting times, the mid-sixties. I got caught up in that whole drug counter-culture, hanging out in crash pads, the whole deal. It was fun. I came to New York as just a runaway kid and I learned a lot out here. Along the way I managed to get an education, mostly self-education. I never graduated from high school, but I have a B.F.A. in filmmaking from SUNY Purchase. I graduated in '77, '78.

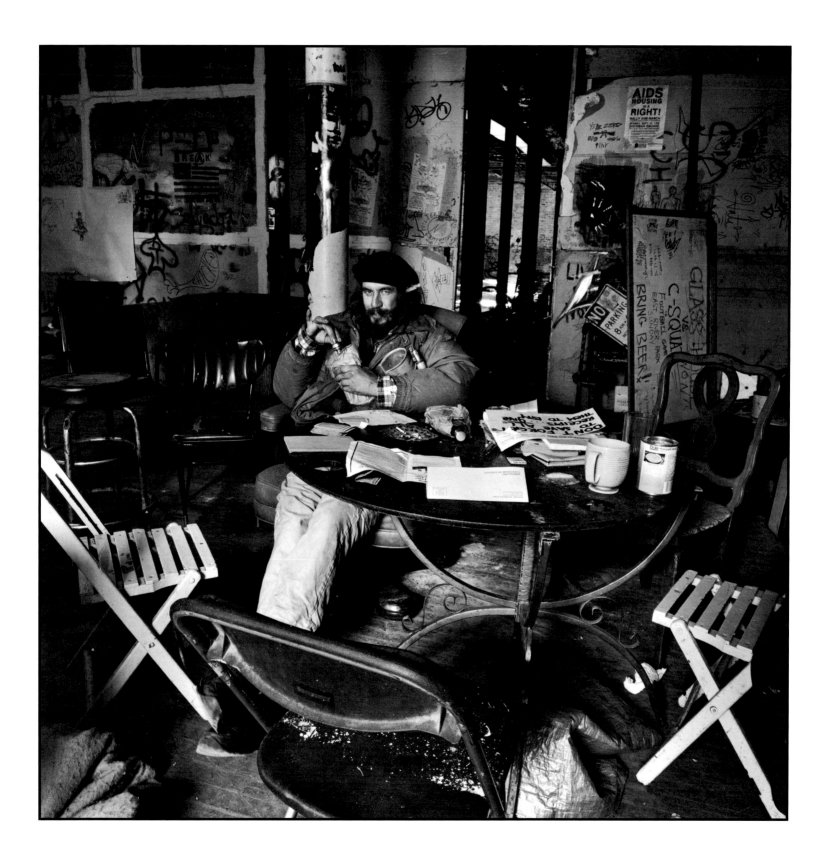

I started out working in labor, construction. Then I worked my way up to cabinetmaker. The thing with being a cabinetmaker is that you're your own boss, and sometimes there's no work and you can't pay the rent. And I had a sort of stormy relationship with my wife, so sometimes she would throw me out of the house, even though I was trying to pay the rent.

Ever since I got hit in the head I have trouble with names. It was a mugging just outside Tompkins Square Park, Ninth Street entrance, as I was coming in. I knew the guy that did it. He wasn't a friend in particular, but it wasn't as though he came up behind me or anything. It caused a blood clot in my brain, the equivalent of a stroke. I was paralyzed on the left side of my body. Some of that has come back. At least I can talk again. I couldn't for a long time. I spent quite a bit of time in the hospital. When I came out, I had no place to live, no place to go, no job, and nobody was going to take me in. I come from a dirt-poor welfare family. What am I gonna do? I had lived on the street off and on for years, but never for more than a couple of weeks at a time—until I had the stroke.

I was shot in the leg once. I caught a ricochet in Chinatown, just happened to be in the wrong place at the wrong time when there was a gang war going on. It broke my ankle, but it wasn't totally shattered. That was in the early '70s.

I'm a compulsive reader. If there's nothing else around, I'll read soup can labels, toilet paper labels. I don't care. I can't sleep without having something to read, and it's the first thing I want to do when I wake up in the morning. I've been writing for the past few years, largely autobiographical stuff. Stuff about people I know, and the life I live, and what it's like to be a crippled, alcoholic squatter. As long as you don't have to live it, it's funny as hell.

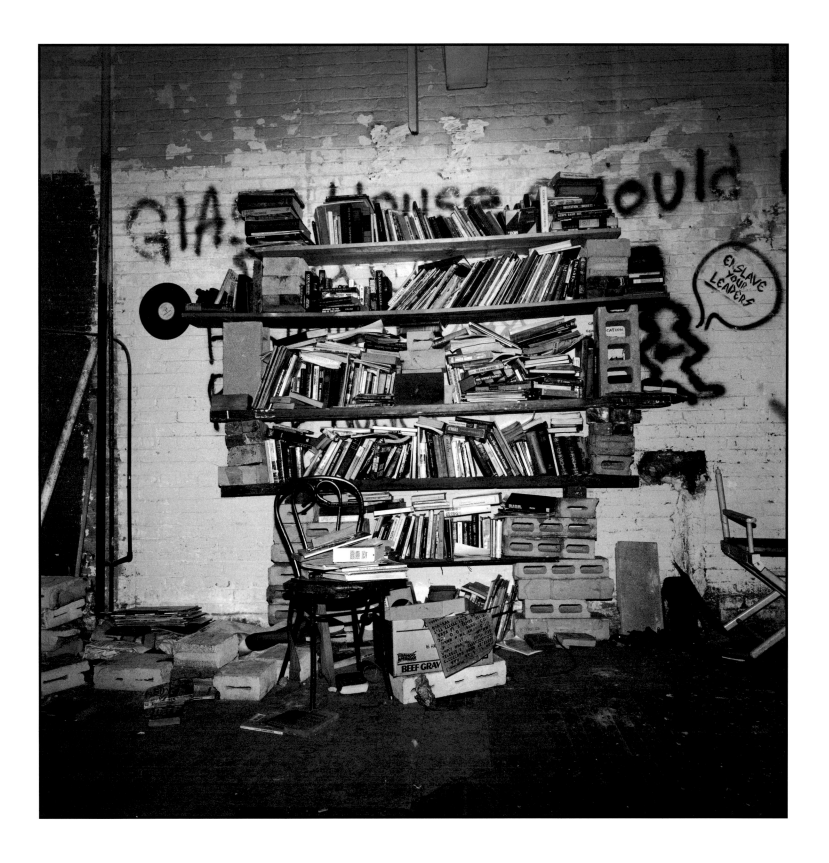

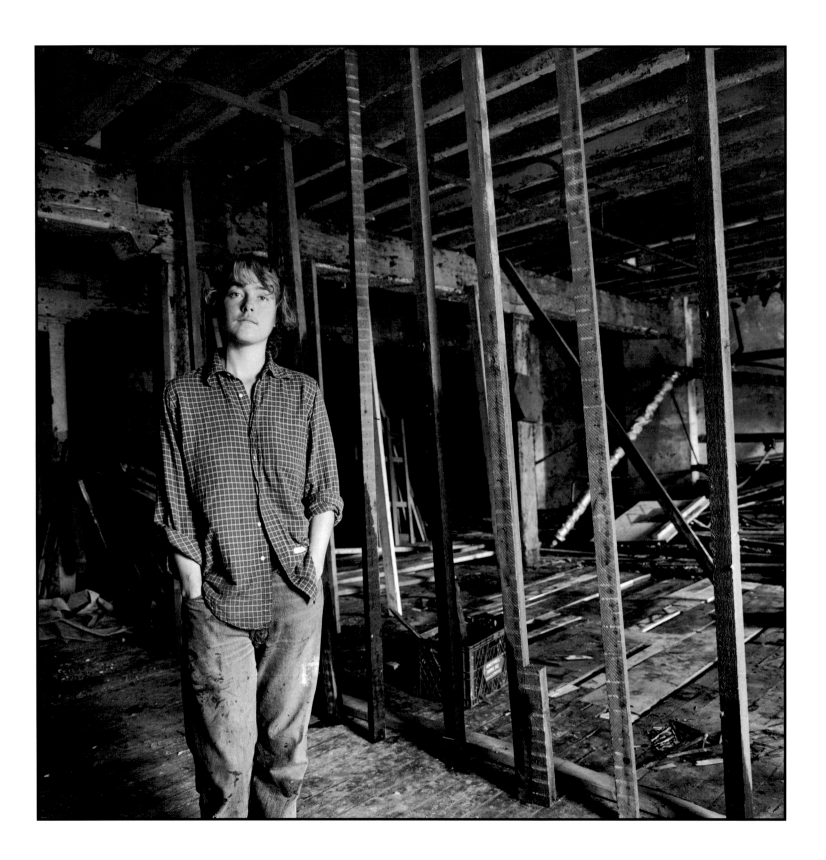

HEIDI

I didn't know about squatting and I had lived in the city for five years. I think that's probably true for a lot of people on the Lower East Side. That's what was unique about Glass House. It was a viable community, but unless you were part of it you didn't know about it. I thought it was a beautiful idea, recycling buildings.

There were times when I was much younger that I wanted to leave home. I didn't want to make an issue out of it. That would make it seem like there were problems between me and my family. I figured that at some point I'd come to New York, so I just let that sort of sit. I left Wisconsin when I was eighteen to go to college.

I remember the first time I walked through Tompkins Square Park. It was almost five years ago, just after I first came to New York. I was still in school. There's a lot of beauty in the city and a person ends up gravitating toward the places and people and events that they want to be near. So I guess that's why I ended up on the Lower East Side. Most recently, I'd been sort of looking for community. I had been working in theater and I felt that there was a certain amount of community, but it was so business related. Putting all your time and energy into the money-making is an entire pursuit in itself. I think that's exhausting for people, and they lose sight of how they live. Theater, for me, only focused on one issue. And when I discussed those things with professors and students, we couldn't find common ground. I wasn't satisfied with that, so I left. It wasn't for me.

So I was looking for community, and that's how I ended up hanging out over here. It's broader. People come together for many reasons, not just the business of theater or the business of restauranting, or whatever. There were other things for me to do and I did them. I wrote and I worked in theater. I worked in a circus, experienced life, and learned a lot.

I worked in plays, assistant stage-managing—props, lights, just helping out. I worked in the Big Apple Circus. I sold tickets, worked in the box office and on the tent crew. We partied a lot. It was fun. We worked an awful lot, too. That was actually the closest experience to squatting that I'd had. There are a lot of little subcultures or communities like that. Squatting has communities like that, circuses have communities like that—extended families.

I worked at a restaurant where squatters came. That was the first I learned about squatting. I learned a lot about the politics of this neighborhood and the city and met people. Dianna's was always busy. But that room was too much after a while. I knew all the people, I knew the room, I knew the jazz music. So I left. I've had trouble finding a place and feeling comfortable in a particular job. I do have a part-time job right now. There aren't any set hours. They're surveys over the telephone, mostly political questions.

I had never been to a Community Board meeting. It's a hangout. I went to see friends. There were two people there that I had the closest relationship to. One was my lover. At the meeting, they had all these discussions, but they didn't allow the squatters to speak. So one of the squatters went down and started yelling, and they still didn't get to speak. When that happened, the energy in the room got really violent, and I moved forward with the group, kind of like, "What's going on?" Then I saw one of the cops being really violent to one of my friends. It was absolutely unnecessary. And I just lifted up my foot to go forward rather than go back. That's all I did. They pulled my hair and threw me around. I had bruises, the whole thing.

The charges were dropped. They dismissed the case in court at my arraignment. They didn't find my name on the computer. That was my first Community Board meeting, and my first arrest.

Then I lost my apartment. We were supposed to have it until September first, but for some reason the woman we sublet from came in to change the lock weeks before then. She was very upset.

Glass House took me in. I was excited to enter into that community, because it fascinated me. They were people who worked at all different kinds of jobs. And it was a chance to really do something with my hands, to build my own space. One member told me where I could find building materials in a dumpster. People told me from their experience how to build a room. They basically said, "Find things and do it yourself." I looked so long for those materials. I even tried to buy them, but they were just so expensive. A couple of people did help me. Scott drew a diagram for the door, and Karl helped me with holding the studs up. But then there was a lot of discussion about house policies in terms of handing out keys. I decided, "I'm just leaving." I hadn't really wanted to go, but people were getting so upset. It was just a bad time in general. I left Glass House for a month.

When I came back to Glass House, I went into a smaller room that was more private, the tiny little room that Max had built. You had to go up the elevator shaft. For people who are afraid of heights, there are certain places they shouldn't go, and that could be said of that space. But it was a place without lots of other distractions or interruptions if I wanted to write or read or just be by myself in a sort of spiritual space.

I thought Glass House was beautiful. There had been so many generations of people in that building, and in the house there were people of all ages. The majority really needed places to stay and were looking for a community because it hadn't been established for them yet, their place in the community. There were always new people coming in from different places with new ideas or new energies about what to do with it. It was a great place to live because it had the ultimate possibility.

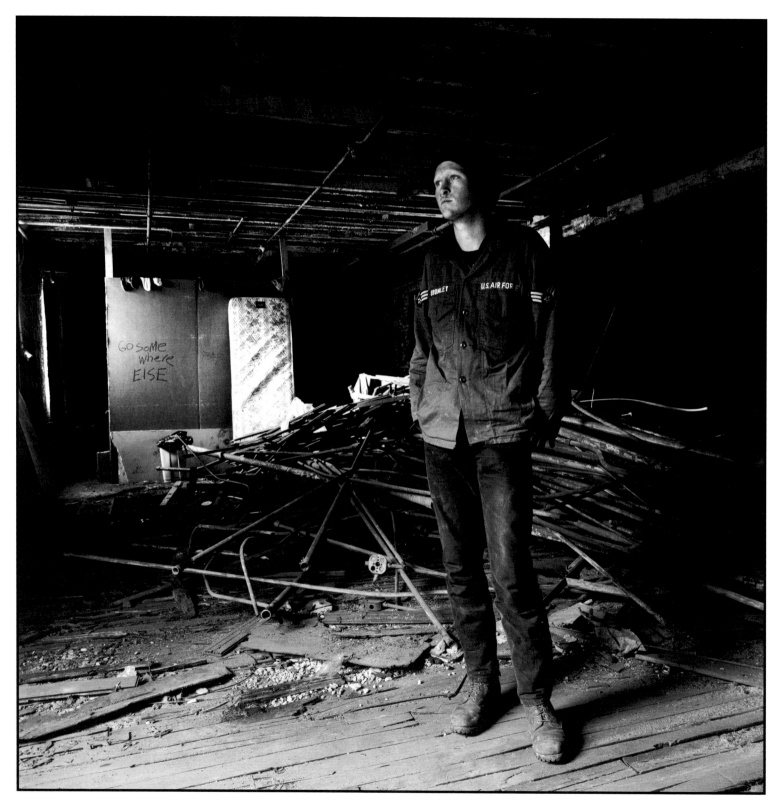

Garth

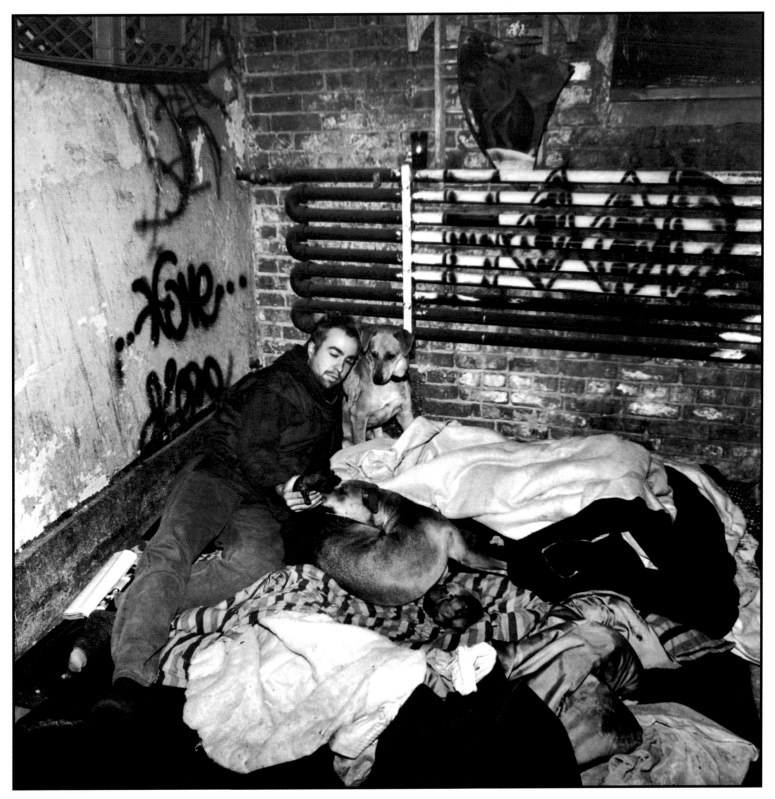

Mark (Gentle Spike)

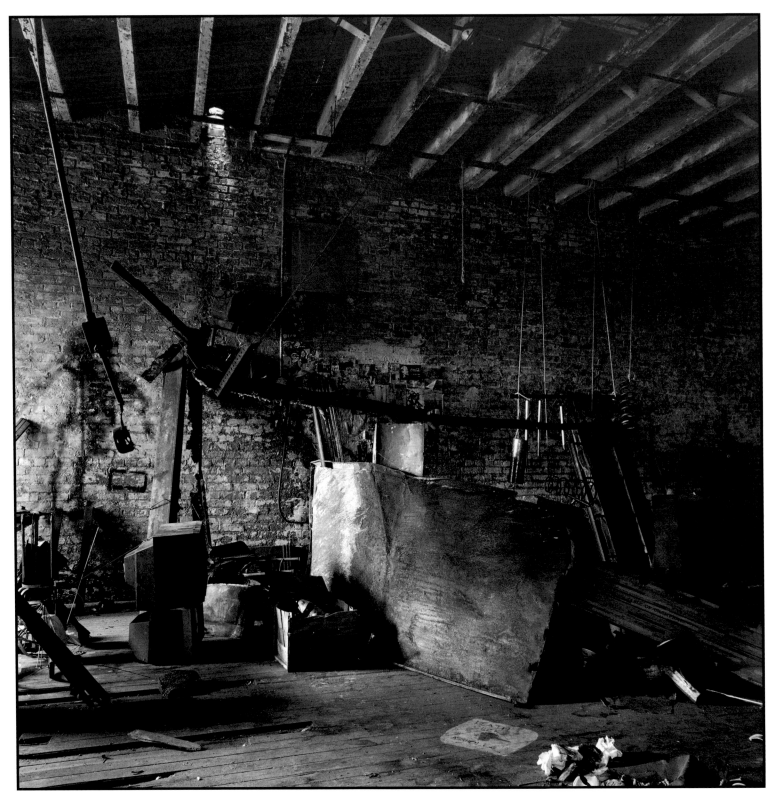

Mark's sculpture

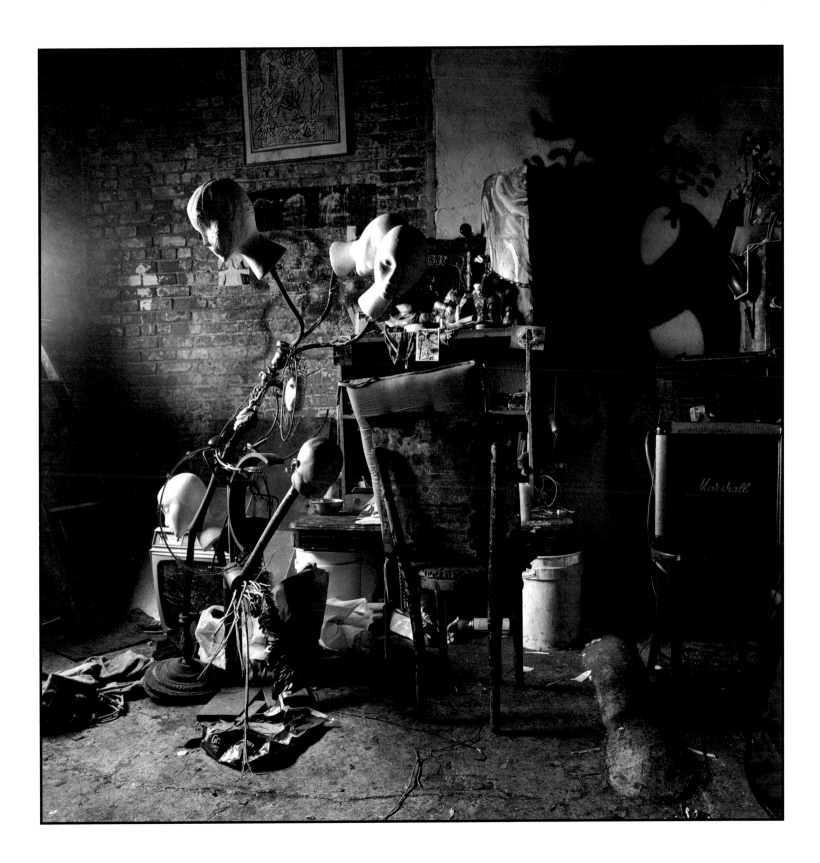

JOHN

I'm forty-nine. I was born in the Bronx. I lived on the Lower East Side from 1970 to '73. After my marriage broke up, I lived on Twenty-fifth Street. In '88 I heard about the riots in Tompkins Square Park. I came down the next day, signed petitions, and got involved. In '89 I was living in "tent city" near the fountain that says, "Faith, Hope, and Charity." After they evicted us, I lived in squats, hallways, and subways. Then I was invited to live at Glass House.

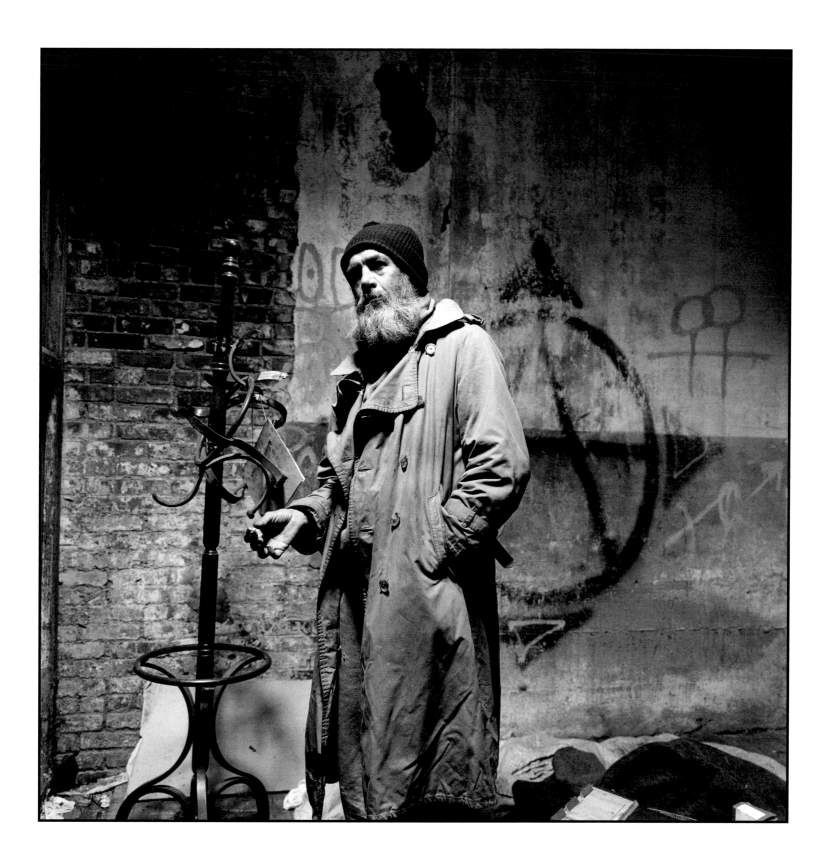

ANGELA

I was born in northern Indiana, Fort Wayne, kind of a big city, but not compared to New York. My mom and my dad had a pretty strained relationship and got divorced when I was about three. My mom ended up taking off and met a guy who lived close to Bloomington, so I grew up there. It's a southern area, but a college town, so it's more liberal. There's a lot more going on than anywhere else in Indiana. My mom lived pretty unstably for most of my childhood. She was always seeking out some kind of relationship that would keep her from being alone, but she always sought the wrong people and went through a lot of really dysfunctional relationships.

My dad—we never were really close, but he always kept in contact. He didn't want us to leave and he was really upset when we left, but he tried to come and see us all the time. For a short while, during my middle-school years, I went to Fort Wayne and ended up staying with my dad for a while. It proved to be disastrous, because my dad and I had a pretty difficult relationship, so he ended up sending me back to Bloomington with my mom. And my mom was really unstable and stressed, so me and my brother pretty much were on our own for a lot of our teenage years.

As I got a little older, I started getting kind of angry. I just hated my life. I hated me. I hated everything. And this hatred just started burning inside me. So I ended up moving out of the house when I was seventeen and I just really started seeking, something, I didn't know what. I ended up running a lot and getting really self-destructive. I started drinking, started using drugs. When I first started drinking, my mom had me admitted into Koala, a rehabilitation center in Indianapolis. You stayed there. At that time all I did was drink. I didn't even smoke cigarettes or anything. But they were telling me that I was a liar and they knew that I did other things and I just hated to admit it. That really frustrated me because I was being as honest as I could. After that I tried being more responsible and staying away from drinking, but there was no foundation in my life. So I just ended up wandering, not knowing what I was doing. And it didn't take very long before I ended up right back in the same scene.

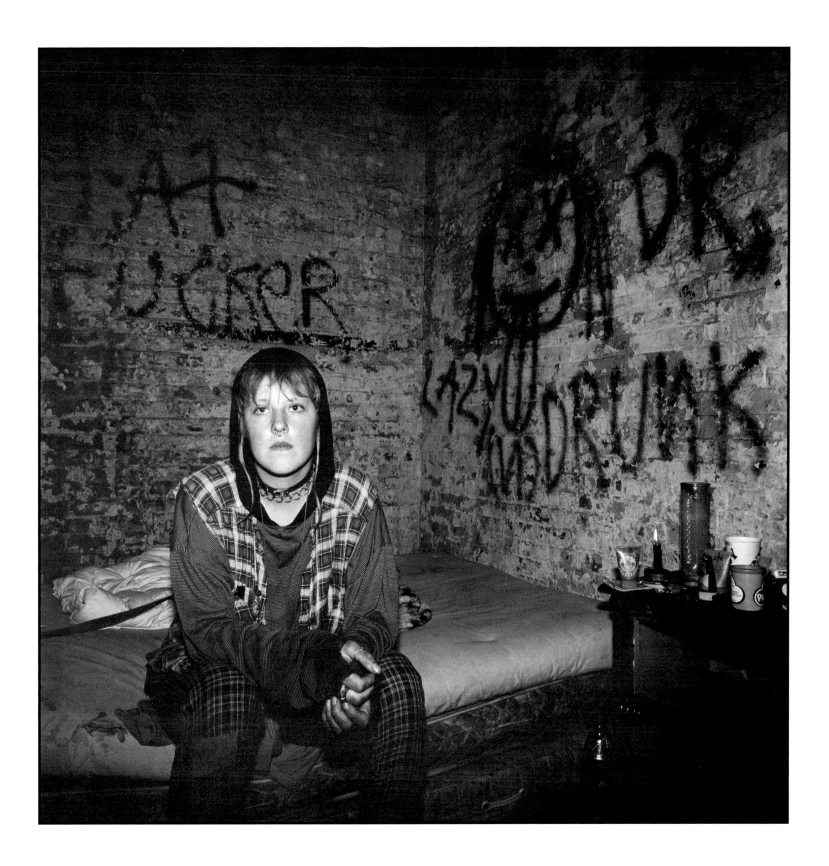

After that, I started drinking more heavily and I ended up getting into a car accident that was pretty severe. I was convinced that God had spared my life and I tried developing a relationship with the Lord. But I didn't really have any kind of example, and I didn't know what to do with myself. I still hung out with all the same people, so it was just a matter of time before I ended up doing all the same things again. I had no strength. At that point I had no goals, nothing to live for. I wasn't suicidal or depressive. I was really angry and hostile. I only sought out things that would destroy me. I had a totally chaotic life. I would just drink all the time and I started any drugs that anybody ever offered me. I'd just take them because I didn't really care.

I wanted to take off. I wanted to travel. My friend Denise was going on a road trip, just to wherever. She traded her car for a van and some money, so I said I'd go with her. But the night before they were going to leave, I got arrested for public intoxication, so they had to take off without me. I ended up hitchhiking. As soon as I got on the highway, hippies picked me up and took me to this place called the Freedom Farm in Freedom, Indiana. The people at Freedom Farm were going to a blues fest in Chicago two days later. So I ended up in Chicago, where I met a guy who had just lost his job, who ended up getting some friends together and took me to Madison, Wisconsin. I asked at a diner, "Where is the downtown area?" They pointed me toward that direction. I couldn't find anybody hanging out, so I walked into a Taco Bell and Denise and everyone from the van was just sitting in there. They all jumped up at once, like, "Oh my god, how did you get here?"

I was pretty much along for the ride. Denise had all the plans, and I just went along. Where we went was never discussed, and I never really asked. I was just there. We'd just go from city to city. When we'd get to a city, we'd all hang pretty close together. We'd just end up going to the downtown area. If someone in the group knew someone, then they would take us to their place, and we'd talk, hang out, get some beer, and that's about it.

We'd pick up people and drop off people. There were thirteen people, two dogs, and a baby at one point. When they went to Minneapolis, they dropped off a few people that were in the van and they picked up some more, and then they'd go to another city. We ended up in Cincinnati, where we met Calli. Some of the people in the van already knew her. Calli was talking about how she needed to get back to New York City. I didn't have any say in it, but everyone was like, "Well, maybe we should go to New York instead of San Francisco."

When we got to New York, we pulled up right on Avenue A, about a couple blocks from Tompkins Square Park, and parked there. Everybody jumped out, and all of a sudden I was by myself. There were eleven or twelve of us and everyone had their own places to go, because everyone had been there before. You travel with these people for so long, and you're thinking that you've got this strong group and you're going to hang out together, then all of a sudden, as soon as we get there, everyone scatters. I don't know anybody and I'm kind of going, "Oh my gosh, what have I done?" So I just wandered around and checked things out. If I'd see somebody that I knew, I'd try to latch on to them and just hang out with them a little bit, to kind of feel my way around the town.

It was kind of scary. I knew the rumors and stories. But I guess my ignorance kept me not too afraid, because I had never been in a really major town like that, a city, I mean. The first night some of the people ended up sleeping in the van, and the rest of them, if they didn't have a place to sleep, went to East River Park. A big group of us slept there on the grassy area outside the track. I slept in a lot of different places. There was a community center behind Tompkins Square Park that had a big concrete platform. You were elevated from the sidewalk and no one could really see you, so I'd sleep up there sometimes.

Denise had a little girl, Eva, and the police were noticing that there was a baby with a big group of dirty people. Eva was kind of dirty looking too, so they were watching her. At one point they confronted Denise and they were talking about taking Eva away from her. The police were standing there talking to Denise, and Eva was behind the police officer's back. A friend of Denise, who saw what was going on, grabbed Eva and took off with her to a Thirteenth Street squat. When the police were finished talking with her, someone told Denise, so she went back there and just stayed, hiding out, until she got her van. Then she left and went back to Indiana. She didn't end up being in New York very long at all.

A guy I'd just met offered to share his room on Thirteenth Street. I stayed there for a while and became really good friends with a lot of the people. But I still didn't feel like I had my own room, which I really wanted, and my own space. Then Calli worked it out so that I could stay at Glass House until I earned my place, the right to be a member of the building. Then I started working on my own space.

During the wintertime, when it got really cold, you didn't go out much. We spent a lot of time as a closer community. People on the different floors would all go to one central area and stay warm together. A lot of people on the fourth floor just ended up migrating to Calli's room because she had a woodstove. Usually whoever got their welfare money would buy everyone beer that night, so we'd all sit around and drink. It seemed like everyone would always just fall asleep, but Jesse and I would stay up talking.

The first thing I noticed about him was that he had very blue eyes. He was tall and really skinny, six foot two, but built big. I thought he was a lot older than what he really was. He wore his hair in long, brown, dirty dreads, with a black cap and a black leather jacket under a denim coat covered in metal studs. Jesse was very punk, very obnoxious, very confident, and a lot of fun.

We'd go a lot of places together. We'd hang out together. Before I realized that I really liked him, he just walked up and kissed me one day on Avenue A. I was really embarrassed because I didn't want that kind of relationship, and people were standing around. I was like, what was that all about? But he just walked off. He didn't even talk to me anymore for a while after that. Most of the time he hung out in the park with other punks like Slug and Sloth and Spike. I think I felt closer to him before he felt close to me. Eventually we hooked up. We were both at the point in our lives where we were so tired of stupid relationships. I was tired of being screwed over by guys, and he was tired of being screwed over by girls. We shared that with each other. I got pregnant right away, but I didn't even know it.

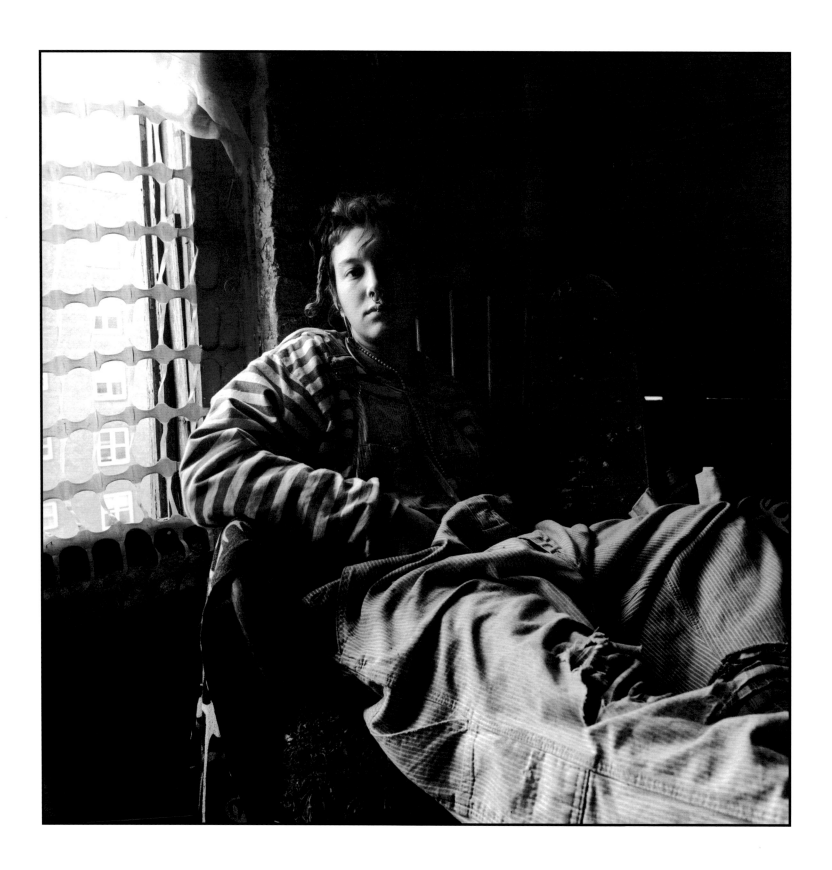

CALLI

I started living on my own when I was thirteen. I was living out on Long Island in friends' houses, garden sheds, in the woods. I went to California when I had just turned fourteen. I was going to Santa Rosa to live with my uncle because I was having too many problems. I wasn't staying at home, and my grandparents didn't like it. They couldn't respect the fact that I could take care of myself. "You're going to go live with your uncle." So I went out there and stayed with my uncle for about a month. The household was so intense, and he enforced such strict beliefs on me like, "You go to school, come home, do your homework, do your chores, take care of the goats." I couldn't deal with that. It just wasn't me. He and his wife were constantly fighting, plus they were going to have a baby soon. There was no place for a child like me.

So, I started living under a bridge. There were these big cement rooms and we built individual rooms inside them. My mother had come out there to try and get me together, and I was just like, "I'm not having it," so she was living under a bridge too. I lived under 101 and she lived under E Street. I started to go to school again while I was out under the bridges. Then the city police burned all our stuff. Because of the law, no matter where you live, if the city evicts you, they have to give you back your possessions. There was a lawsuit against the city. They lost in court and the city had to pay us, but I only got fifty dollars. It was nothing compared to losing all my stuff.

During the Gulf War demonstrations, I learned a lot about squatting from the different people who were coming up from San Francisco. And that's when I started really getting into what I believe in.

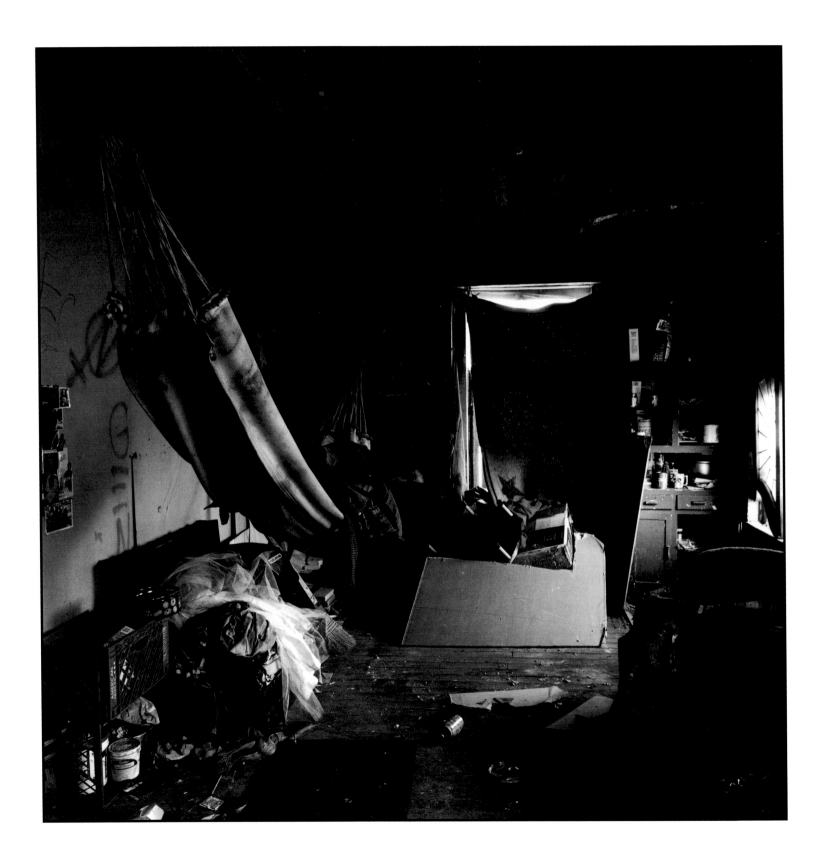

I left California right before I turned sixteen. I came back to Long Island and tried to move in with more relatives, settle down, and get back into school. But my mom was so busy trying to get her own life together that she didn't have time for me. Her boyfriend wanted no strings attached. She wanted me to strike out on my own. So I left and started staying out on Long Island in the woods again. I was in the tenth grade. I was going to the alternative school, but I was being seriously threatened by the school system for being outspoken and politically involved. They were trying to put me in a foster home and put me on anti-psychotic drugs.

I decided to come into the city, because this is where I felt I belonged, more or less. I had been to New York a couple times and talked to squatters who were panhandlers. When I came to Glass House, I thought I had found a party that never ended, but when I was struggling to get off drugs I realized that I had found people in my life who really cared.

When my mother was young, she had conflicts with her parents. She sees why I'm the way I am. It took her a long time to be able to understand that. Before I started squatting, she didn't like the way I was. At first she couldn't accept the way I acted, the way I dressed, my Mohawk haircut, my body piercings. Now she knows how much pride I take in Glass House, and how much I love the building, and how much I've put into it in the past two years. Now my mom comes and she'll hang out with me and she does workdays on the squat. She wants to be here with me, as a friend but not as a mother.

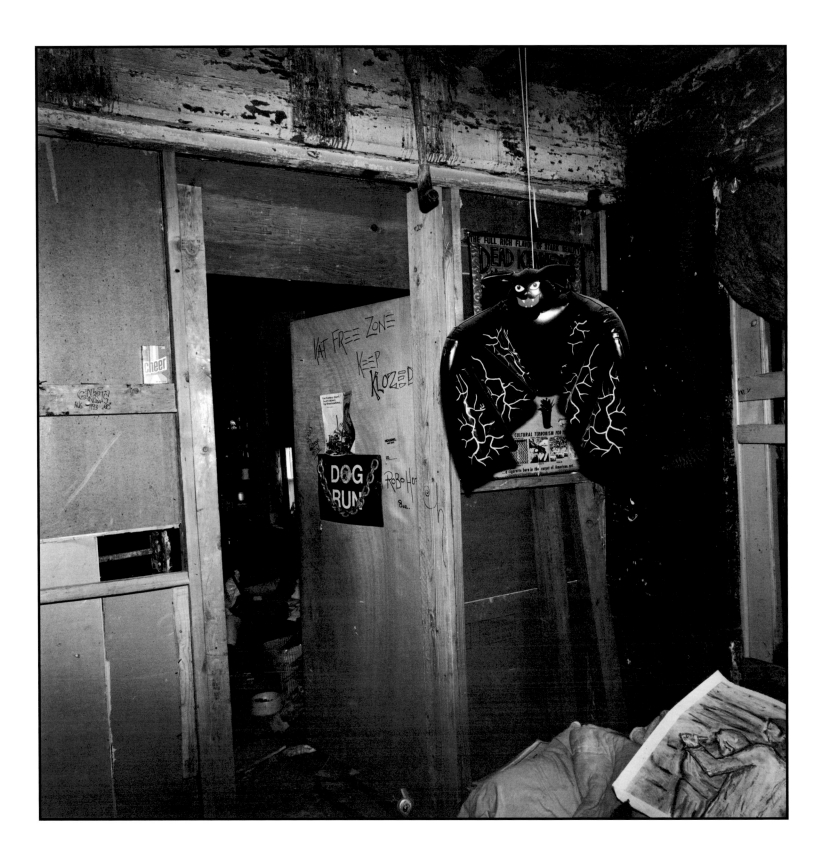

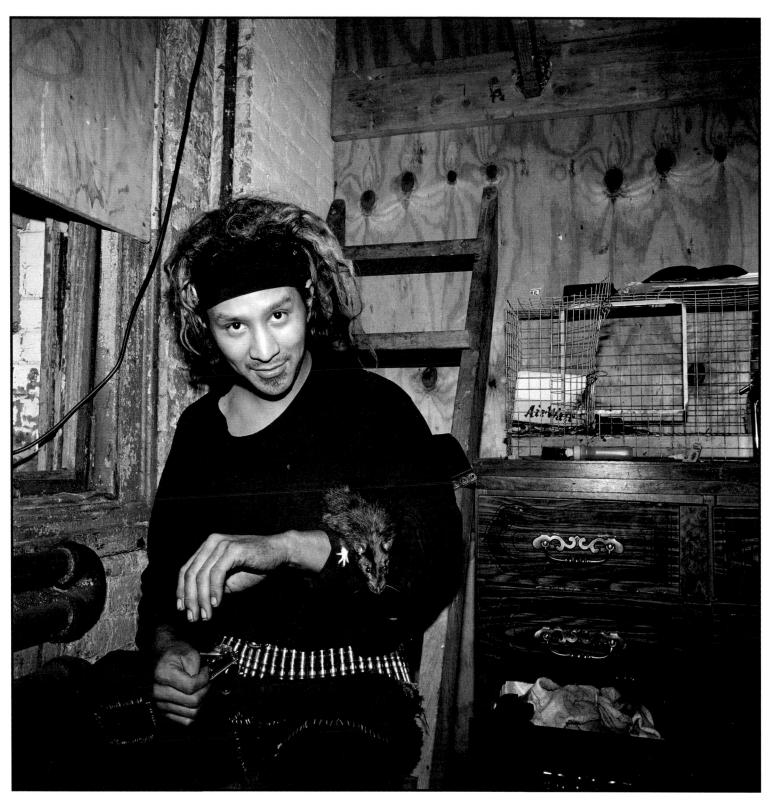

Resident and his rat, Nicodemus

Exodus

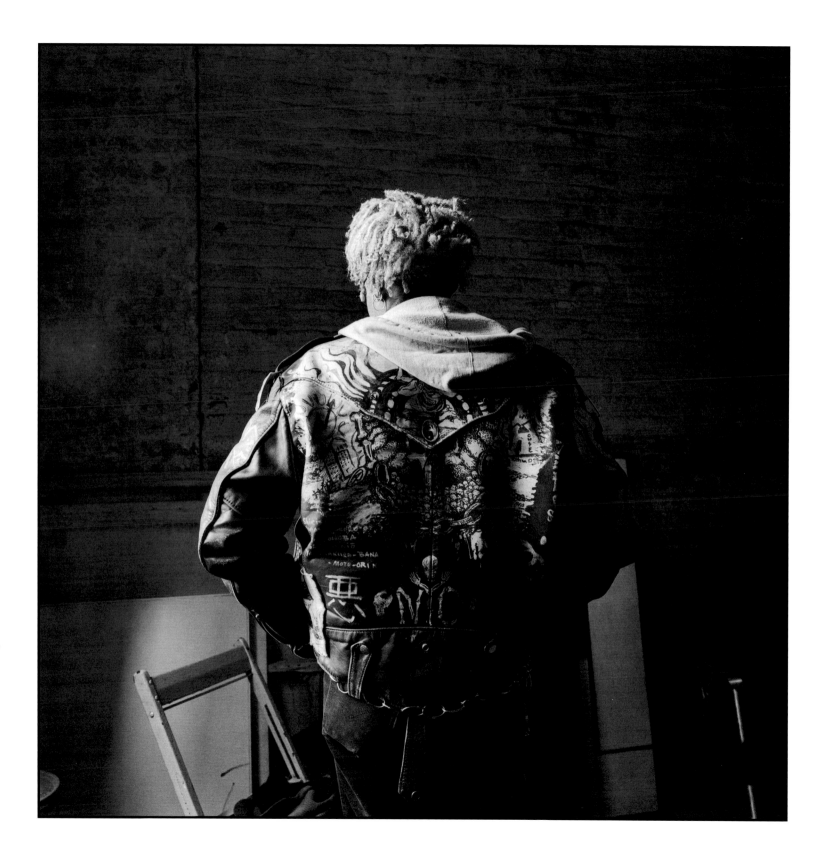

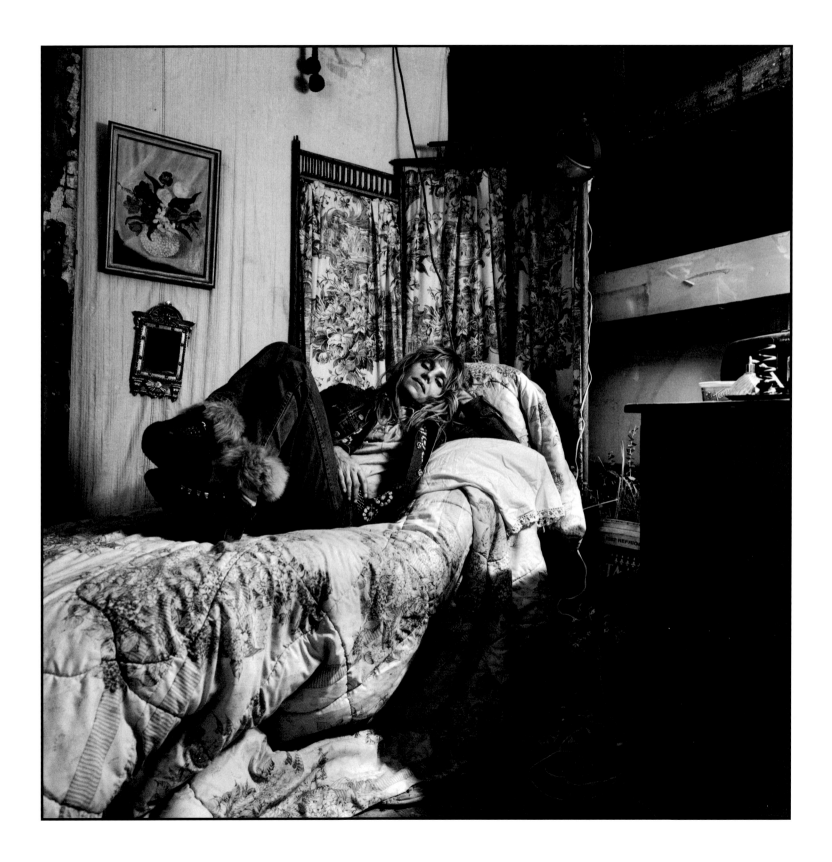

LINDA

Donny Linda was always a very up-front person and very protective of her stuff. If she thought someone was taking liberties with her property, she wouldn't hesitate to get right in your face about it. If Linda liked you, she'd go through hell for you, and if she didn't like you, you'd best just avoid her.

I first met Linda when she was living at the Chelsea Hotel. It was after a three-day marijuana legalization conference in New York, and she had volunteered her apartment for an afterparty. Chelsea was a great space. Linda had taste, in furniture, hangings, and stuff, and always was a sharp dresser—kind of avant-garde, but stylish. We didn't meet again for a year and a half or something afterward. It was a party at the Pyramid to celebrate the release from jail of a mutual friend of ours. Linda and I actually started hanging around together a lot during the Gulf War. As usual, I was looking for sponsors for a political project and didn't have the connections to some people who had provided money in the past. Linda was socially conscious and, compared to us at least, had an income. We hooked up a thing where she provided matching funds for a poster and campaign against the war. That's what actually started us hanging out as friends. She had a silkscreen business, screening the green cloths for gaming tables and doing chips for casinos. She'd been involved in the manufacture of gambling equipment for a long time before I ever met her.

In the early '90s, Linda was losing her rental and afraid of becoming homeless. And I said, "Well, homeless you're not going to be." We had been getting a bunch of real bozo recruits at the building. It seemed like every new person who had come for the last six months was some kind of fuckup, and I was getting very frustrated. I remember sitting in the La Plaza Cultural Community Garden and saying to a friend of mine, "I don't want to hear from any new people. Anybody who's fucking new will have to have their shit together, be organized and serious. I don't even want to know as far as another batch of drunk punks."

And it wasn't fifteen minutes later that Linda comes in and tells me she's about to become homeless. It was like, no, that's not happening. She was exactly the kind of person I was looking for and hadn't been finding for six months.

One of the funniest things, so classically Linda, was that for many years she had had the same fellow that came around once a week to clean her place, including at the Chelsea. So here it is, she moves into a squat but still has a housecleaner. She says, "I still have a good relationship with my housecleaner. I really don't want to let him go." It was the only time I ever heard of a squatter with a housecleaner. Linda didn't want to see the guy lose income that he depended on just because she didn't have an apartment.

She definitely did more than her share of the work, that was for sure. I can remember watching Linda spending days and days shoveling incredible amounts of rubble and stuff to make her space. Like everybody else, she was given just a totally undeveloped part of the building that was basically a big pile of rubble and told, "Well, just do what you can." Even though she'd come from a more middle-class background, she never got or sought any kind of breaks that everybody else didn't have. No job was too difficult or dirty. I saw her fall through floors several times. She'd be shoveling a big pile of rubble and then all of a sudden, there'd be a "crack" and she'd just be falling. It was difficult and dangerous work, patching up that place. But we all did it.

Linda had a lot of varied interests. She was a licensed airplane pilot, a licensed ham radio operator, and was into phone and computer hacking. She was always reading stuff on electronics. She was a member of the New York City Garden Coalition and she was very attached to the old beatnik poet scene. I met Herbert Huncke, Allen Ginsburg, and Gregory Corso, all through Linda. At the same time, she might be hanging out with Richard Hell or Pete Missing. From the Beat scene clear through the punk scene, Linda knew everybody.

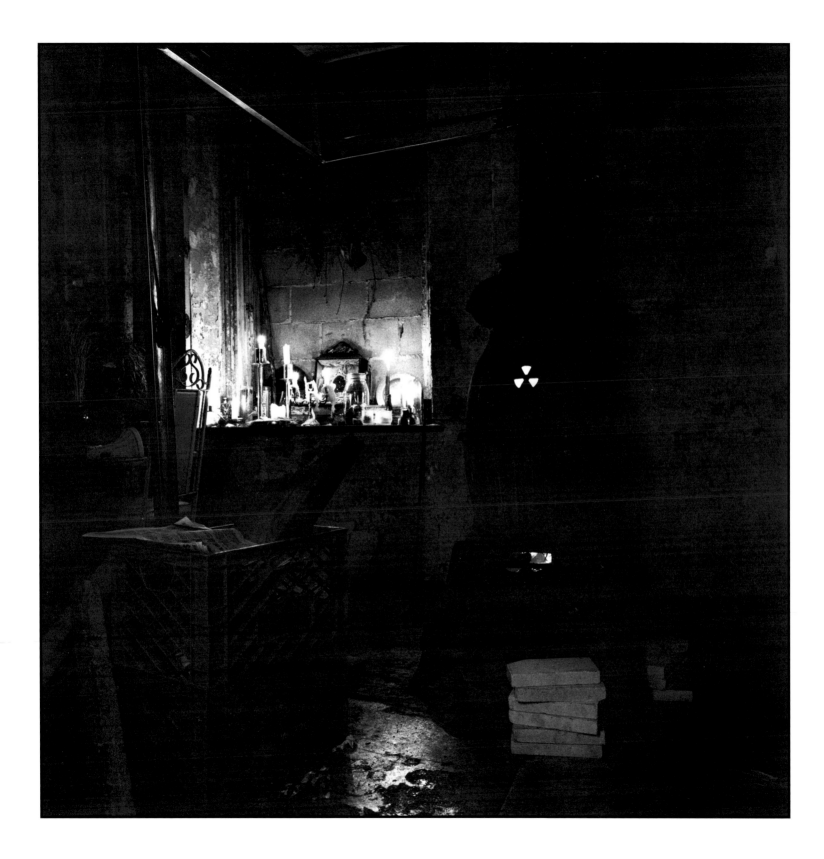

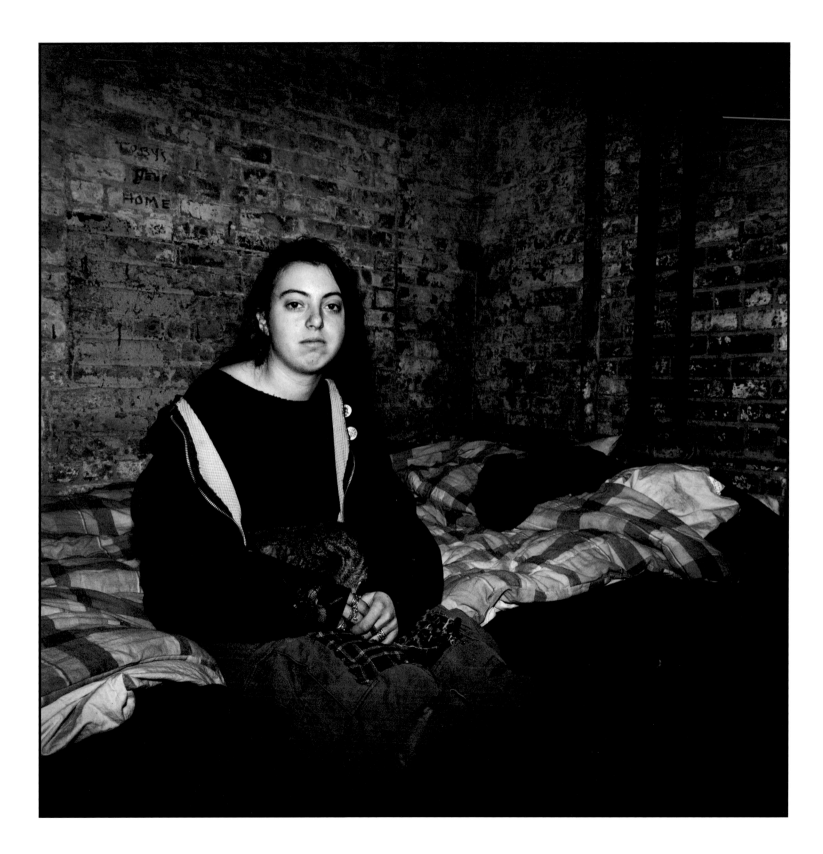

TOBY

I met Linda through living in Glass House. My room wasn't really finished, and when it got cold, she was always nice, "Do you want to come and sit in my room?" She had a big wood-burning stove. The fourth floor was one big party, always a bunch of people hanging out. Sometimes, if I just wanted to get away and be by myself, I'd go down to Linda's room and sit and talk to her. One time she was going out, but she let me stay, "It's warm and there's TV, just hang out." She was always happy. I often think of her in a long skirt or something ruffly. Sometimes I see people that even look like her a little bit.

I was born in 1974 in New Haven, Connecticut. Both my parents were pretty young. They had lived right around the corner from each other—my mom was friends with my dad's sister. I think my mom was eighteen when she had me. It was the '70s, tail end of the hippies. They were just starting out. My dad was in the Vietnam War. He had been back maybe a year or two before I was born, but he doesn't really talk about it. I remember being little and my mom waitressing and going to art school at night. My dad did construction work. He still does.

I was pretty young when they split up, maybe between ten and twelve years old. I remember it all. My dad drank a lot. I don't think my dad wanted to split up, but it had to happen. He'd still come over. My parents maintained a good friendship.

I went to two high schools. The High School in the Community was my favorite. We did American Herstory, which is the history of the United States but through women's history, and classes in African-American film. It really made an impact on me.

After I graduated from high school, it was like my mom's second childhood, her teenage years. She had graduated from high school and planned to go on to college, but then the unexpected child. I had held back eighteen years of her life. She went to school in Connecticut for massage therapy. After a friend moved to Hawaii, she moved there too.

I actually had plans to go to college and I'd gotten into NYU, but my mom had just lost her job, and they still counted her financial situation from the year before. So I thought I'd take a year off and then maybe go back to school, but it just never happened. I stayed and worked in Connecticut in a coffee shop for six, seven months. I saved money and then I made the move here.

A friend introduced me to one of her friends, Tracy, and we got an apartment together. I should have realized when she said, "Meet me, there's this really cheap place to eat," and we met at Benny's Burritos. That isn't my idea of a cheap place. I should have known then. We had roommate problems straight off, two totally different people. She had already graduated from college and was a bartender and really clean. I lived there for only two or three months.

She just didn't like my choice of friends, which were a lot of people who squatted and people who were in Tompkins Square Park. Thinking back now, I should have respected her wishes a little bit more, but I'd always try and have people over when she wasn't around so it wouldn't make her uncomfortable. She had her boyfriend there all the time, but she didn't like my friends coming over. If I have something, I want to share it. I had running water, so if you wanted to come over and take a shower that's not a problem with me—I don't pay a water bill. She didn't like that. She was like, "We're not running a youth hostel." Her boyfriend once told me that I wasn't living in reality. I was like, "You're telling me that Tracy is living in reality because she went to college and graduated and is now living in New York as a bartender? I can be a bartender without four years of college."

Well, Fourth of July, people had come over after we'd gone and watched the fireworks. Tracy was away for the weekend and the woman who lived below me was the aunt of my landlord. She complained to her nephew and said that I had all these people over and that all these things happened.

So all my stuff was in the hallway, piles and piles of stuff, and there was a note saying, "The locks have been changed. You can't live here anymore." I guess if she didn't get rid of me, she was going to lose the apartment. I was like, "Oh my God, I can't believe it." I didn't know what to do. I didn't even question it or argue. But I didn't leave New York. For a while I slept in the hallway upstairs in that apartment building without anybody knowing, because I still had the key to the front door, just not to the actual room.

Then I moved into Glass House with Calli. I'd met her in Tompkins Square Park. One night, I remember, she came and slept over in my apartment with some other people and Generic, her dog. I guess she was having problems in Glass House, so she didn't always stay there.

I'd been in Glass House before, but at my first house meeting I was scared and intimidated because I'm pretty shy. I didn't want anyone to have the wrong impression of me as being some drug user. I'm not. After I did workdays and hung out and people knew who I was, then everything was fine. I just wanted people to like me. I got along with everybody.

I had a bunch of money saved from when I worked in the coffee shop in Connecticut, then Streetwork helped me get food stamps and government cash assistance. Streetwork actually came to us. Tod came up to us on Avenue A one night with this woman, handing out information about what their place was. They were doing outreach. Me and Calli started going up there and checking it out. It was pretty good, but you could only come on the same days as your worker. Our worker was Tod, so we'd go on Tuesdays. You could go in and they'd give you a bag lunch. You always had to talk to your worker, just meet with him and say what was going on in your life. Then you could take showers, and they had a room where you could wash clothes. They had medical people who would come once a week. If you didn't have ID, they'd help you get ID and stuff. It was a good place.

We'd panhandle on Avenue A or Broadway if we wanted ten dollars to eat and get some beer. I always did it with somebody else—Calli would bring Generic. Sometimes people would harass you and say, "Why don't you get a job?" Sometimes people are like, "Oh, just help these people get on their feet." Sometimes people are like, "You shouldn't own a dog if you have to panhandle." Some dogs get treated better living with people who squat, because we're with them a lot.

Me and Angela decided to build our rooms right across from each other and have a living room in the middle, but we never got that far. I had the walls up and a door and my bed and everything. Markus and Sean helped, because Plasma, my kitten, died right when we were putting my walls up and I was really upset. A dog had gotten out and attacked her. There were lots of dogs and cats. Shere Khan was this cat that was brought over from Foetus. We always joked, "That cat's been squatting longer than a lot of people." He was a kitten at Foetus, then he moved into Glass House, from Glass House he went to Dos Blockos, from Dos Blockos he went to Fifth Street, so he made all the houses.

There were so many different people, like Donny and Kim and Linda. I probably never would have met them, or Merlin, or John. There were these hippies who would serve food off their bus called "Everybody's Kitchen." All of us would meet there at the same time at night. They got this following—people would just come and collect around them. Then the cops came and made the bus leave, so people just camped out on Ninth Street. It was getting cold, so we decided that they could come and stay inside Glass House. We let them stay behind the community room wall with their shopping carts. They wouldn't listen to all the rules, like sometimes they'd use space heaters when we told them not to, and they wouldn't attend house meetings so much, and they didn't really come to workdays, but they were pretty quiet.

Maybe because I was an only child, with just my mom and my dad—and my dad moved out—I don't like being alone. It was nice having this whole big family all of a sudden. They were all my brothers and sisters. I liked its diversity. There were young people and old people all living together. I don't see that so much in the other squats. It was nice to come home to a bunch of people instead of to a little apartment somewhere. You could always walk into the community room at Glass House and people would be there doing something, even if it was just Merlin sitting there rambling on with his Wild Irish Rose. Or somebody would be cooking down there, because we didn't have enough power to cook in our own rooms. You always saw people. There was always somebody there. It was like living in an apartment building, but knowing all your neighbors and everyone being in your business. It definitely was my home.

I think squatting in general has been really good for me. I have a better sense of dealing with people, more confidence in myself that I can do things on my own. If something breaks, I don't have to call somebody to come fix it. I can figure it out myself.

Glass House was wonderful, but sometimes you had conflicts. A lot of people were drinking, getting drunk every night, and out of hand. They would always be apologetic afterwards, "I'm sorry, I didn't mean it. I was drunk." It was easy to get sucked into drinking all the time, and hanging out, and doing different things. It was everybody. I guess I'd say I like to drink—Midnight Dragon. I drank in high school. It's easy if you're around something so much. You can just go and do it and not think, and not realize that months and months and months have passed, and you're still drinking every night.

When Joeleyn and I were going to Philadelphia to visit friends, we just hopped trains. Joeleyn had hopped trains a lot, but it was the first time that I'd ever done it. But before we got on the train, a cop driving by saw us climbing up this hill to where we were going to wait for the train, and he stopped us. I had my camera with me, so we told him we were there just to photograph trains at night for a school project. I don't think he really believed us and he waited. A train started coming and Joeleyn says, "This is the train. We've got to get on it." Then he saw us on the other side of the train. He was yelling, "Hey, you can't do that. Don't do that." Joeleyn tried to make me get on first. She wanted to make sure that I could do it before she got on. She said, "You've got to do it. Watch the ladder, and just follow it, and just do it." I kept waiting and missing the cars. She was getting frustrated with me, and I was like, "I can't." I finally did it. I got on. It was moving, but not that fast. You kind of run with it and grab onto the ladder. You're hanging on and running along so that your feet don't slip. When you feel comfortable enough, you just pull yourself up. I was able to do it, but then you have lots of adrenaline too. Some people get on trains that are moving pretty fast.

But the cop actually had the train stopped, and they searched for us. And I was like, "Oh my god. I guess I'll know if they find her." She'll yell, "Toby come out." But I just stayed hidden in this hole on a grainer. There's all different kinds of cars and these were carrying grain. The ladder goes up, it comes down, and there are a few rings on it. You get in, it's like a V, and there's this little hole. It's big enough in there for a person to crouch down and curl up. I'm little. I don't know how big people do it. I hid down, covered myself up and just stayed. When they came on the train, they didn't see me. I could hear the cop going, "I'm too old for this. Gotta climb up on the train and look." And they gave up. They thought we'd jumped off and ran away.

So then it was just fine, until the train started slowing down. It was in the middle of nowhere. I was ahead of Joeleyn, so I didn't know where to get off. I jumped off the train when it was slowing down and went back to Joeleyn's car and stayed with her. We wound up in Harrisburg, instead of in Philadelphia, and had to get off there.

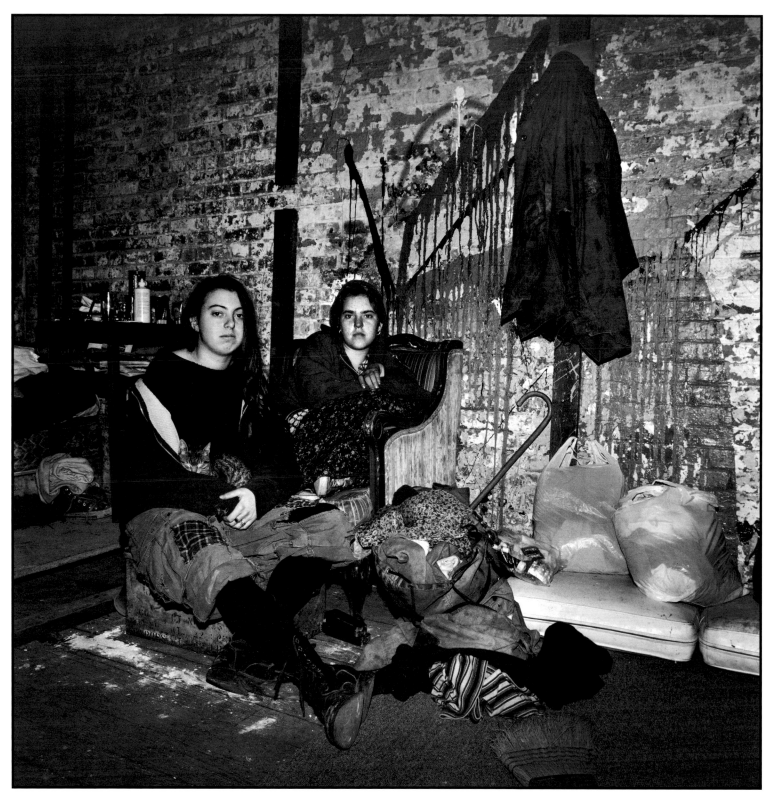

Toby and Erica

ERICA

It was just me and my mom until I was ten. We were on welfare, living in Bellingham, Washington, but we always moved around a lot. My mom was going to school. Then she had a son, got remarried, and we moved to Seattle with my stepdad. When I was fourteen we moved to Sedro-Woolley, a small logging town. There were a lot of hicks, but there were also a lot of stoners, rockers, and skateboarders. That's when I first started taking mushrooms and smoking pot. I got kicked out of school because I never went.

We moved back to Bellingham the summer before my sophomore year. I went to high school there for a couple months, maybe not even that. Then I went to Alger, which was more of an alternative education. You didn't go there except to check in. I didn't do that for very long either. I really never did well in school. I didn't fit in. I thought it was bullshit. It was not what I wanted to learn about and it was not how I wanted to learn. It was like, "They're teaching me all lies." It probably didn't work for me because of my home life, and because I smoked way too much pot.

I really had an unsettling feeling about what was going on in the world and all the problems. I read a lot. I also took a lot of acid at a pretty young age. I always wonder how much that had to do with how I perceived the world around me. Maybe it opened my eyes to more things.

I was the only person in my grade who dropped out, so I kind of lost contact with those kids and hung out with people older than me who weren't in school. I just met them around town, in cafés, or hanging out.

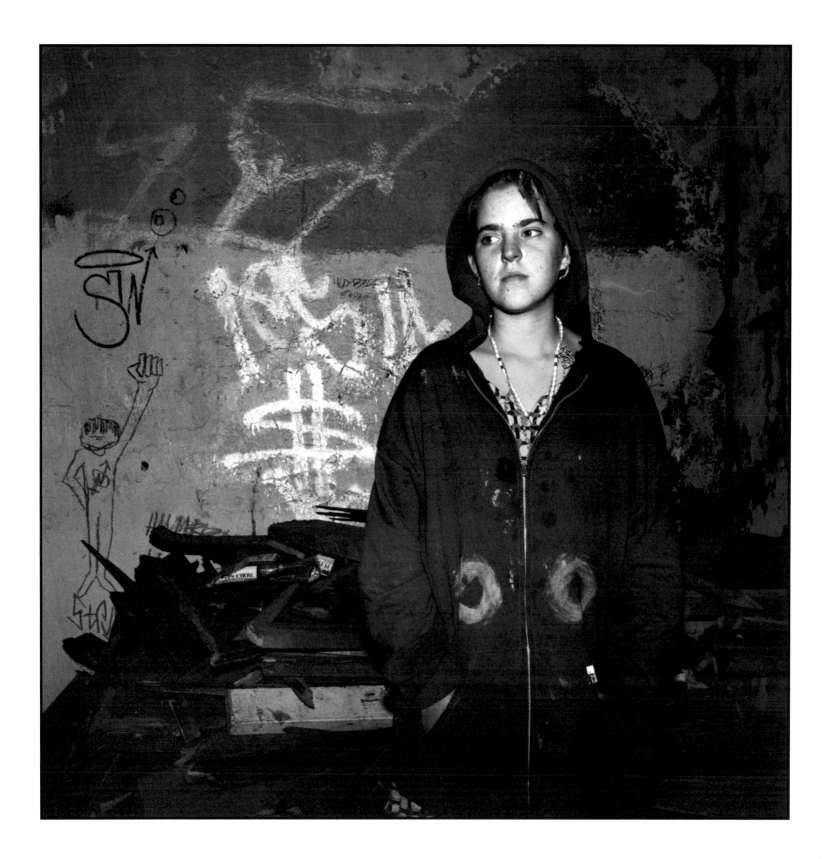

The first time that I left Bellingham on my own, I went down to Berkeley in a carful of people, just to go someplace. Berkeley is a pretty political place. It's so contained. It seems like they have their own little bubble there.

But then I ended up back in Bellingham. It was summertime, so I was just sleeping wherever we were hanging out, sometimes under the Fairhaven Bridge, a beautiful old bridge with a creek that runs down at the bottom. We'd hang out at the top and drink. When the sun would be going down, all the bats would come out. We would also sleep at the beach. You had to walk down the train tracks to get there, so no one would be around. We'd always build fires. I loved being down there. There was a pretty big group, and some of my older friends had homes where we would stay.

We found out about an anarchist gathering in Philadelphia from Markus. He'd grown up in Bellingham and didn't like it here very much, but he had come back to visit his grandmother. So I headed to Philadelphia with a girlfriend. She was Canadian, fourteen years old. I was fifteen. I think my mom was probably pretty sad and tormented about me leaving, but she was that way anyway. My friend and I tried to hop trains out of Seattle, but we got kicked off the train, so we hitchhiked the whole way to Philadelphia. It took a couple weeks, but we had a long stop in Minneapolis.

We rode in cars or picked up rides at truck stops. It took us three nights and two days to get to Minneapolis. A lot of times our rides would drive through the night. Every time we got dropped off, the cops would come. They were on us five times in twenty-four hours, between three different states. They would call our parents, and both of our parents would tell them that we were emancipated. It worked. The cops would yell at my mom, "How can you let your daughter be here?" and make her cry. We were also harassed by weirdos, who thought we were in a cult, and a stupid worker bitch at a truck stop, who said if we weren't gone by nine a.m. the pigs would run us out.

One trucker tried to tell us that we had to pay for the ride and he grabbed me. There were two of them in the truck. One was driving and the other was trying to get one of us in back. I said, "Fuck off. Let us out." They pulled over and dropped us on the highway in the middle of nothing—Nebraska. I didn't have time to be scared. I was just dealing with what was going on in the moment, all the time. Those trucks have beds in them and we used to just fall asleep back there, until that last truck, then never again. I can't believe that I survived.

Markus never showed up at the anarchist gathering, but we ran into Sean, who had been with him when he came through Bellingham. We stayed at a squat called Happy House. Some people from New York were staying there too. I really didn't have any desire to go to New York, just going to Philadelphia was my goal, but New York is where I ended up. I got a ride, with as many as could be squished into a tiny car. Sean invited me to stay with him at C Squat. That's where I turned sixteen.

I had strep throat on my birthday. Sean went out and panhandled so that I could get some antibiotics. I went to a gay-lesbian clinic, which was a really good place because they would treat you for free.

At C Squat, all the spaces were taken, but at Glass House, if you were willing to work, to build your own space, you could stay. But you had to be sponsored, which meant two people there were willing to vouch for you. Exodus sponsored me, along with Donny.

The roof leaked so badly that it would rain in my room, even though I was only on the third floor. The sound of rain could be comforting, but I knew it was making my home collapse.

We had a lot of animals. Plasma, Shere Khan, Chicken, and Dinner were cats. Ramsey, Generic, Tar, Nesta, Magpie, D.O.G., Goblet, Grumm, and Brutus were dogs, plus there were lots of puppies, like Nixon, Abida, Camilla, and Bacon. Calli had a rabbit named Stew Bunny and a rat, Herman Vermin. Lisa had G.S. Rat. Another pet rat was Nicodemus.

Sometimes I'd scalp tickets to get money for beer and building supplies. I hated doing it. We would go to Madison Square Garden and spend the night in line. Right before we walked into the door, this guy would hand us a couple hundred dollars, and we would buy as many tickets as one person was allowed to buy. We'd give him the tickets when we got out and we would get fifty bucks. I did it quite a few times. A lot of people would do it.

Toby and I went panhandling at Port Authority Bus Terminal, and the cops stopped us and asked how old we were. I didn't lie about my age because I heard that in Port Authority they could arrest you for panhandling if you were older, but not if you were younger. They let Toby go, but the cops arrested me, called my mom, then told me that they were going to deport me back to Washington. It was pretty much the same with all the police, "Your sixteen-year-old daughter is dirty and homeless and living on the streets." They kept me a really long time in Port Authority, then two cops drove me way into Harlem. We just kept driving out of the city and away from anything that was familiar, and it was slowly getting poorer and poorer. I was like, "Oh shit, where are they taking me?"

They dropped me off at some youth home. It was dinnertime, and I was the only white kid there. Everyone was really nice to me. One of the boys said, "You look beat. Why don't you stay here and take a shower and clean yourself up?" I just wanted to cry. I wanted to get back to the Lower East Side, where I knew my surroundings. I said I just needed to get home. They didn't make me stay. The lady gave me a subway token and two huge bags of canned food. It was more than I could carry. The boy walked me to the subway and along the way I gave cans to every person I saw who could use them.

Finally I got back to the Lower East Side. I was just feeling safe when some kids egged me, right in the head. It was the night before Halloween. That was the first time I went to Port Authority to panhandle. And I never went back.

I also earned money babysitting for two kids of a couple who lived in a squat on Thirteenth Street. It was so well organized and really clean and safe. They even had an intercom. It seemed very conservative compared to Glass House.

I first met Log in Tompkins Square Park. He was with Cabby. We went back to Cabby's room to blow up G.I. Joe's. They tied firecrackers around the dolls and lit them. Log didn't really live anywhere, but he would stay at C Squat or Glass House, wherever. He was so easy to be with. I felt comfortable with him right away. One time we went down in the basement of Glass House and got really stoned. He carried me around on his back, because I didn't have any shoes on, and we explored the basement. It was really eerie, filled with rubble and not much space to walk in. There was a cesspool and a couple rooms where there were these shrines. It looked like someone had been staying down there.

Glass House was a big building. It could be very scary. When you entered, the first room was so dark. If I got back in the evening and I was the only one in the house, I would have to leave. I didn't feel safe. I didn't like to go down to the bathroom by myself at night. I was fine when I first moved in, but the longer I lived there, the more freaked out I got. There was so much empty space, and you just didn't know what was going to be there. There could be lots of peepers in the house. There were lots of holes, pipes carried sounds, and doors weren't locked. A lot of different people had a lot of different reasons for being there. And there was a lot of drug use, which makes people a little weirder than they normally would be. I used drugs. It probably made me feel more paranoid.

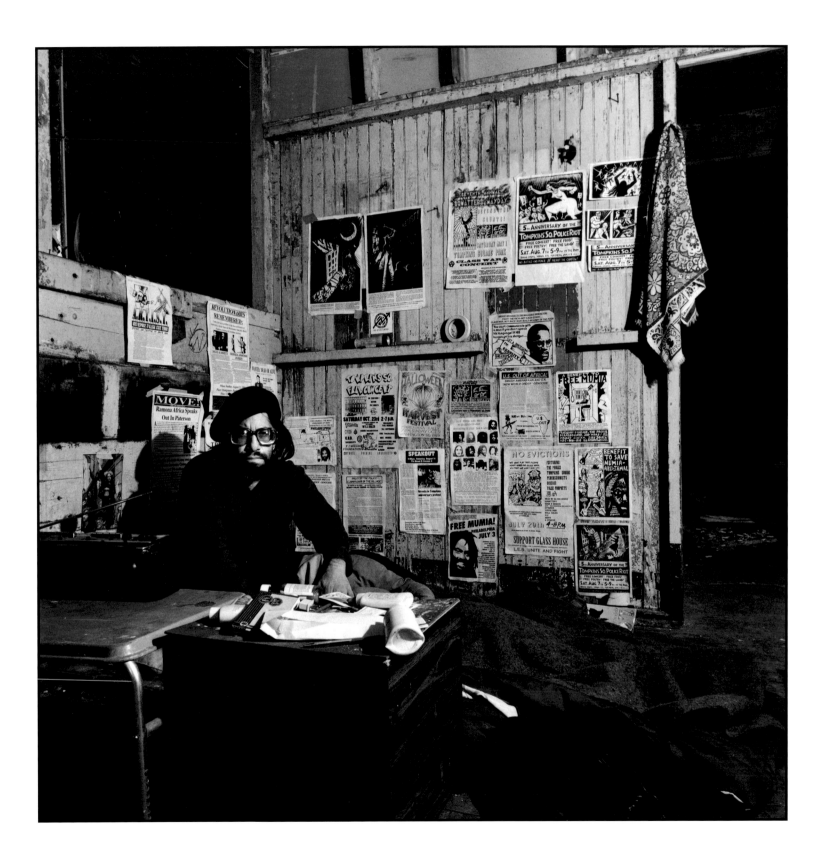

KARL

I was going to school at William Patterson College, 1986 to '90, studying political science and history. Ran out of bread, couldn't afford the place anymore. Ran out of financial aid. I got arrested in my apartment. I tried to explain it to my landlord, but she didn't want to hear my side. It's a long story. So I just left. Stayed in the YMCA for a while and then I came to the Lower East Side. Was homeless for winter of '90. I slept in Tompkins Square Park when it was still open twenty-four hours a day and there were fire barrels. There was still a movement down here, a real movement. Things have changed since then. I decided that I was tired of living on the streets.

There's a squat down near Houston Street called P.E.S.T., which stands for Planet Earth's Scum Tribe. I just banged on the door, and this guy named Brad opened it, and I asked him, "You have a place to stay? You have any space for a homeless activist?" He knew me. He said, "Yeah, I talked to you before. You're all right. Come on in. I'm going to the Rainbow gathering. Watch my space for me." He gave me the keys and he didn't come back. That was in June. In September, I officially became a house member and I stayed until we got evicted in March. There was no back to the building. There was a front where everybody lived and there was a rubble heap. Supposedly—we never got the real story on it—some bricks fell off the back of the building, and we were evicted. There were only two people there at the time. I was at a meeting, planning a demonstration for the next day.

I'd been commuting between Jersey and the Lower East Side since '87, taking part in the scene down here, going to speak-outs and concerts and stuff. When I came down here three years ago, I knew nothing about street corner agitation. Then a friend of mine ended up in jail over his activities and I went to court for his arraignment. He had a thousand-dollar bail put on him. A woman on Avenue A said, "Karl, why don't you tell people what happened. C'mon, Karl, get on the box." There was a milk crate set up across from the park entrance on Avenue A. So I did. I got up on the crate and I made a speech. And I realized, "This is easy. It's also fun."

I've been busted for assault on a woman cop, and I didn't even do a goddamn thing to her. I was arguing with her, and all of a sudden I'm knocked to the ground by about eight cops. Handcuffed. And I'm charged with assault, because when she was helping subdue me, she put the cuffs on, fell, and banged her knee. So I wound up spending four days in jail and a five-hundred-dollar bail. I been arrested about five times since I been down here: once for assault, once for riot felony from the Memorial Day riot, once on St. Mark's Place protesting the buildup to the Persian Gulf War, once for a metal jam in Tompkins Square Park during that war. I can't remember the last time. So, there's no love between me and the cops. If the cops hate me, I hate the cops.

It's been three years since I've had a job. Foot messenger. One Friday afternoon the owner said he wanted to paint the office and he gave everybody some time off. He told me to call in for my assignments. So Monday I called in. Nothing. I figured I had a day off. Good, go back to sleep. Tuesday, same thing. All right, two days off, that's fine. Wednesday, I was, "Wait a minute, something's wrong here." So I got up, I went over there, and peeked in through the mail slot. Everything was gone except for the telephone. We were supposed to get paid the week after. I looked for employment and then just said, "Oh the hell with it. Fuck this shit."

I stayed at Foetus squat for a couple of months, before the fire, then people told me about a glass factory around the corner. People were squatting there very quietly. My friend Cheese moved in, so I moved in as his guest. I picked the foreman's office because I wouldn't have to make a space. I've lived here a year and eight months. In winter, icicles hang from the ceiling, icicles hang from the bucket under the sink, water freezes on the floor in the community room. It's literally freezing in here. It's supposed to be twenty-six degrees today. It's at least sixteen or colder in here. When I first moved in, Donny warned me, and I didn't really believe him. But it's an old factory. It gets incredibly cold.

Different people have different strategies to stay warm. There are people who really go to town on their space and they'll build it, they'll Sheetrock it, plastic it, insulate it, and it's nice and warm. I'm just too goddamn lazy. I go to sleep on the floor. I got a heavy sleeping bag, four really good solid blankets—pull 'em up to my chin, I'm fine.

I'm forty-two. I'm happy with the way things are. If I wanted to earn some money, I could. But I'd rather do what's—quote, unquote—illegal. I won't say what. It's underground economy. I get up when I want. I go to bed when I want. I'm mercifully, happily unemployed.

DONNY

I was a high school dropout, sophomore year. Pretty much had a nervous breakdown. My whole life was a war zone. I haven't gone through anything on this scene that could match living there. I had to fight all the way through. I had family problems, but I also had major problems with the community. I did not fit in there from the get. The cops, the skinheads, the crackheads down here can't hold a candle to those rednecks up there when it comes to brutality. You couldn't be a radical in high school because there was nobody to be radical with. I woke up in puddles of blood and piss so many times that, like I say, what goes on down here—I don't get impressed with riots. From grammar school, junior high, high school, I was beaten unconscious so many times it's amazing that I know the difference.

At one point we created a crew. It was a pretty awesome, pretty wild thing. We were well on our way to running that bloody high school. But then there was a falling out, and that's when things got really hairy. I was used to fighting the rednecks. I had gotten in fistfights with them since second and third grade, but when I had a blowout with that crew—I mean those guys were dangerous.

At the time, my relationship with my parents was definitely not good. They were as down on me as the people that were stomping me on the foot every day. So my home life was one disaster and my school life was another one. I was a hunted animal. I was worried about surviving, not passing, and I wasn't making it. I tried not to have anything that I cared about.

Kent, Cornwall, Warren, Washington—there's tons of tiny little towns around Litchfield County—Goshen, Morris, Bethlehem. I've lived in almost all of them at one time or another. The rural area up in the northwest corner of Connecticut is where the big New York State woods kind of rips across the border.

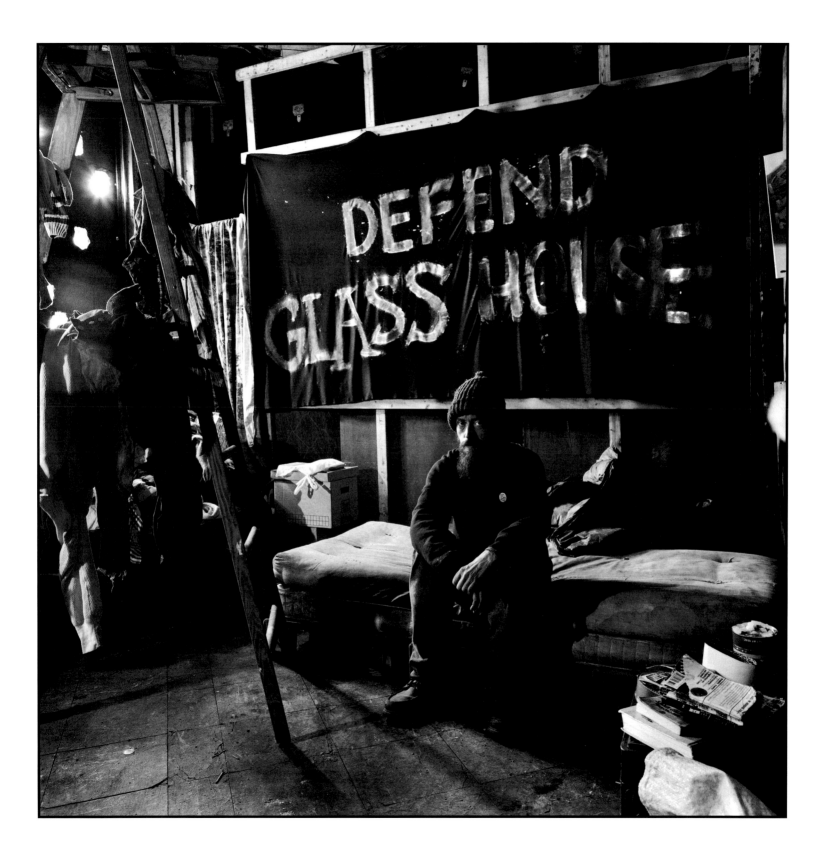

I had a keen scientific interest, which naturally led me to be a materialist, which naturally led me to be an atheist. I was an atheist by age eight. I'd say that was the first step outside—as an atheist, as a bisexual, later on as a user of recreational drugs. I became a political radical much later.

I was always a person with strong opinions and an alienated side, but more of a counterculturalist than really political. Then I happened to be out in San Francisco during the White Night riot of '79. That was the first thing like it I'd ever seen. I came back east shortly after that and didn't really get involved until they organized for the Surround the Pentagon action in 1981 in D.C. I did that D.C. action, came back, picked up a bunch of leaflets, started looking at them, seeing what else was going on. Finally I got to a point where I'd go to a city because there's an action and grab every leaflet I could. If that town was boring, I'd go somewhere else. As the country has gone further and further to the right, the traditional strongholds start getting floods of refugees—New York, San Francisco, and Berkeley. It's happened over and over and over. Things get too hard on the East Coast, go west. Five years, six years later, it's too hard on the West Coast, come back east. Except right now both coasts suck. I don't know what you do.

I was involved with the Lower East Side scene first with the Yippies—Youth International Party. I was staying at 9 Bleecker faction. The squatters' movement had kicked off in the early- to mid-eighties and it seemed like the way to go. Actually, squatting is something the Yippies called for even back in '68. In the chapter on housing, it says that urban centers are full of empty abandoned buildings—take them over, fortify them, call them home. Why feed the greedy landlords? Nobody really took it as far as we did back then because rents were still relatively cheap. But suddenly that chapter of the book made more and more sense. A bunch of us from 9 Yip came down here and got involved in the squatting scene quite early.

I'd squatted other places before I came to New York City, squatted a couple of abandoned houses in the country, squatted an abandoned radar base. I'd just been doing a bunch of local traveling around, moving back and forth, in and out of the city. Technically, I was staying with friends, but it was kind of a cramped arrangement. But when the whole tent city came together, I made the move into Tompkins Square Park and spent the spring, summer, and fall there. I think it must have been 1989. I literally moved in. I was one of two people who actually gave spaces up to move into tent city.

We were winning things right and left, both in the streets and in the courts, for a good three years. We were the only park in the city without a curfew, because we fought. We went from the announcement on the radio the day before the riot that there would be a curfew in all city parks, to the day after the riot with the mayor on the radio saying that there would be a curfew in all city parks except Tompkins Square. And that's what held for three years. We proved that just straight up in your face could work.

Then we won the fire-barrel battle, which was long and hard-pressed that first winter. They started it as a way of harassment, busting homeless people for burning fires in barrels to stay warm. We took something like thirty-eight arrests that winter defending fire barrels. We had fire hoses turned on us in hard winter, fought it to the point where—partly because of the excellent work of lawyer Stanley Cohen—we actually wound up with permission for six fire barrels. Because the city had to admit that if people were allowed to stay there, they had a certain responsibility to see that they didn't freeze to death. Of course, by that time, one of us had frozen to death because the police had come in and put an old man's fire barrel out, and the old man died on a park bench. He was quite a nice guy, one of the many we've lost since I've been involved here. I try to concentrate on the fun of this thing, but it ain't all fun. I've lost a lot of friends.

The loss of Tompkins Square Park in '91 was one of three blows that seriously damaged the Lower East Side. The three big setbacks were the loss of 3BC squat, the sabotage of our books at the bookstore, and then the park. That was our final breaker.

I only had one arrest before I came to New York, a disorderly conduct in a bar one night, back in my late teens. Since then, my record says arrested eight times, three on my present record, but I actually calculate it's more like forty-one times. The worst thing that I was ever charged with was assaulting officers with weapons in '91, '92. Those charges didn't stick. They were totally baseless. The possession-of-dynamite charge came out of the encounter when Tompkins Square Park first reopened. I wasn't even in town for the big riot of '88. I had just come out of jail in New Orleans, where Pat Robertson had had me arrested by the Secret Service for harassment at the Republican Convention. So I got out of jail the next morning, launched a project called Draft Dodgers for Quayle, and then the following day flew back to New York—the first time I'd ever flown in my life. What a trip. I'm on probation now for felony riot on the same night that they accused me of the assault—the '91 Memorial Day riot.

I've been at Glass House for a year and five months, since the beginning of last September. I like to travel. It's really only these last couple of years of probation that have made me a Lower East Side homebody.

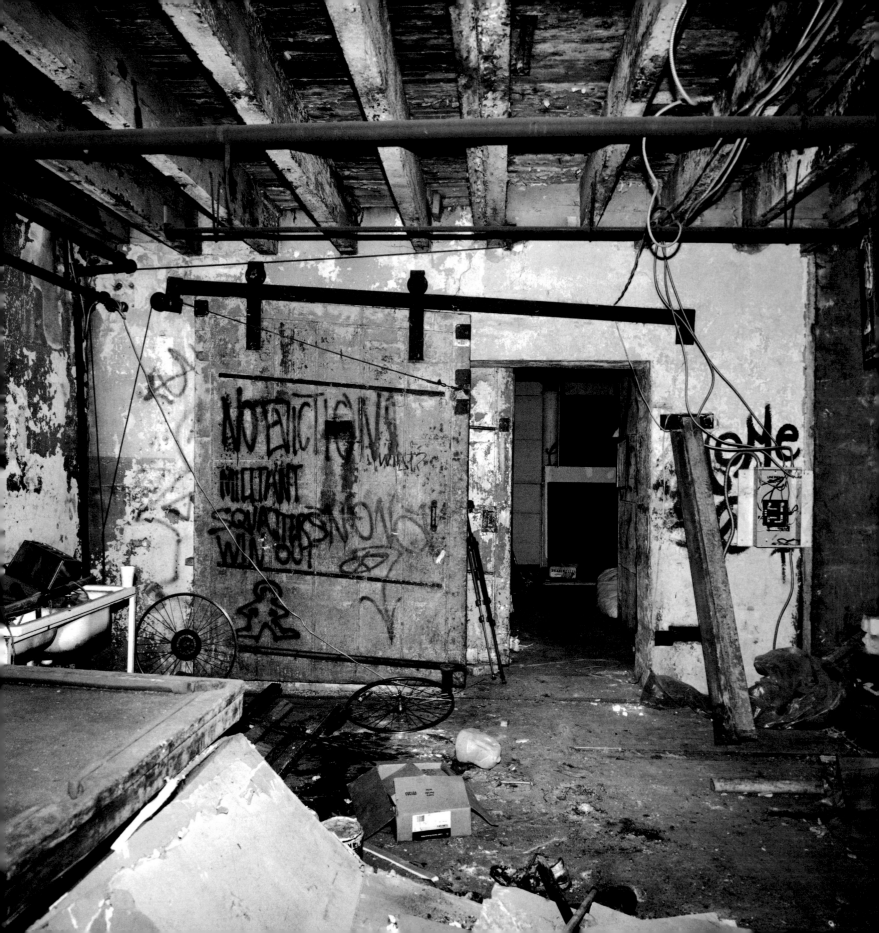

PREMONITIONS

Although the security system at Glass House thwarted several unexpected visits by fire department and city officials, by late December residents were uneasy.

Donny Someone called the fire department with a false alarm. They were easily persuaded that there was no fire and they left. But we had another visit four days later.

Karl New Year's is coming. That's when evictions usually come up, between Christmas and New Year's Day or just after New Year's. Glass House is not out of the woods yet. We've probably got plenty of big battles to go. If they want to fight, I'll stay, but I'm not going to jail and getting my head busted open for people who don't want to fight. There are people who have gone as far as dumping piss buckets. I'm not beyond that. It probably could turn into a major riot. We haven't had a riot on the Lower East Side in two years, not since Memorial Day.

Calli Since July, I've been having a recurring nightmare. In my dream, I wake up and I hear yelling outside. It's really cold and it's snowing. I go to the window, and there are all these cops outside. Somebody throws something out the window and cops start coming toward the building. Then I wake up.

FEBRUARY 1, 1994

Karl It was about twelve-thirty, one o'clock, in the afternoon. I heard the fire engines coming down Tenth Street. The sirens stopped. I threw the covers off, threw my shoes on, ran to the community room, looked through the peephole. Bunch of fire engines, bunch of cops outside. I ran around, waking up everybody that I could.

Donny People went off to negotiate with the fire marshal and it seemed things were cool. I really didn't expect too much to come of it, based on the experience of a few days before.

Kim They said that they had to come inside and check to make sure there was no fire. We said, "Okay, but just let us go inside and tell everyone first, so that they don't freak out when they see police and firemen in the house." But they said, "We're not going to wait for you to do that," and they started ripping the door off the hinges.

Donny We threw up the barricades. It took forty-five minutes of chopping before the first barricade was broken. They were on the bottom floor, but negotiations were still going on outside. As soon as this situation started getting hairy, I started figuring out where the hell I was going to hide, because I could see that there weren't enough people out there on the street to back us up. Barricades are just a stall until you get enough crowd. If you're not going to get enough crowd, then it's just a matter of time. So I found myself left with a situation where there was no way to fight, nowhere to run. Time to hide. I later heard that people actually negotiated away the three barricades.

Karl Eventually, they made an agreement to let the fire marshal and some pigs in, so Moses could show them the wood-burning stove and they'd leave.

Kim We escorted them through the building. Our dogs were barking, and the police told us to take the dogs out, so we said okay. The whole time they were promising us, "We're not gonna throw you out. We're not gonna make any arrests. We're just gonna make sure the building's safe for you." And we fell for it. When we went outside, they threw us out.

Karl It was a trick. They tricked us out of the building. After Moses showed them the wood-burning stove to prove there was no fire, he got arrested. Then another person got arrested.

Calli I saw all these fire trucks and all these police. The police were in riot gear and they looked really hateful. They were breaking down our front door with sledgehammers. You could tell that this was the end. They came up the stairs. They had semi-automatics. They said we had to leave. I had my puppies in my room and they said I couldn't take them. They were not even two weeks old. They shoved guns in our faces and said, "Leave." This time it wasn't a dream. I didn't wake up in my own bed. It was really over.

Donny I'd always kind of looked at this eighteen-inch by twelve-inch metal air duct that was bolted to the ceiling of the second floor. It meandered all over. I'd seen an opening, ages ago, and I'd kind of thought about it. So I pulled myself up a two-by-four, then forty feet down into the air duct. I could hear crashing and smashing. I wasn't sure whether the house was full of police and squatters or strictly police. I didn't know that there had been a double cross and that the barricades had been taken down. I didn't know that a beam had been thrown off the roof at the police, and that everyone was out, that I was the only one left in the building.

Donny When initially they searched the building, they missed me. One cop got suspicious because a stool was sitting below, but he didn't do anything about it the first time. When they came back later with dogs, they got to talking about it, and shined their lights down the air duct. I got caught. They had me spread-eagled against the wall and they brought the dog in and let him bite me in the leg, the ass, and the arm. Then they smacked me in the head with a flashlight a couple of times. I realized that the cops had come through and smashed up everybody's space. They concentrated on the nice spaces—furniture, beds, walls, and stalls. They just smashed up everything.

I came out of jail with dog-torn clothes, a tube of toothpaste, and a toothbrush—all courtesy of the state. And that was it.

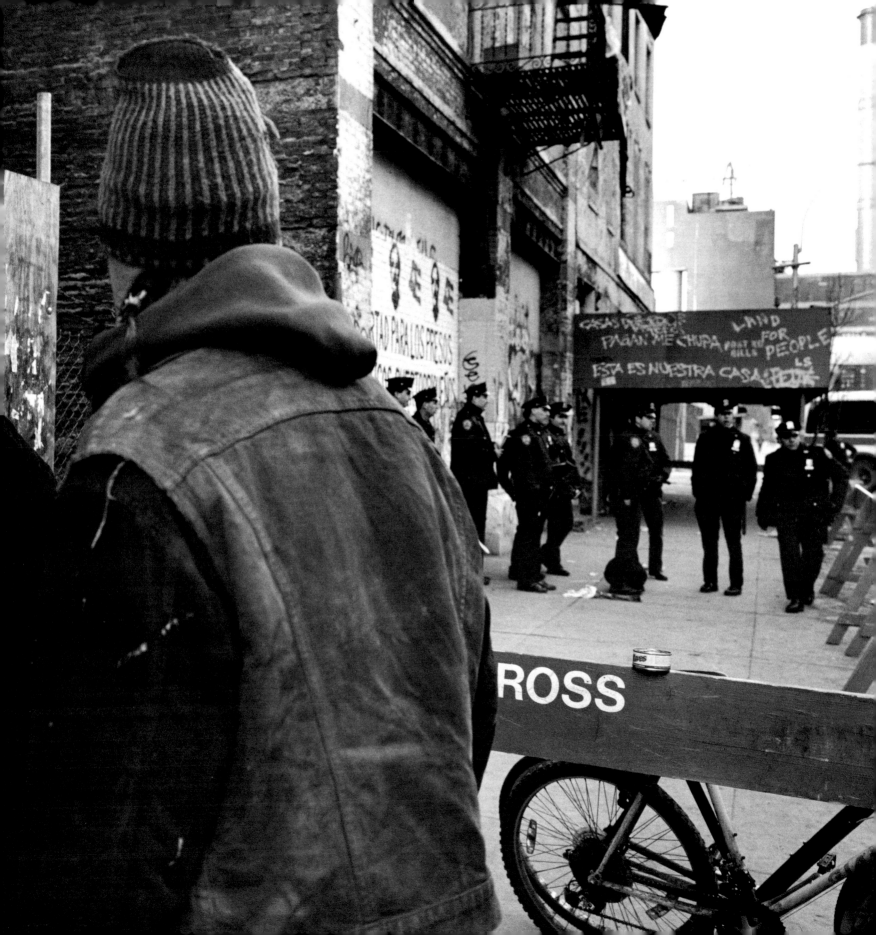

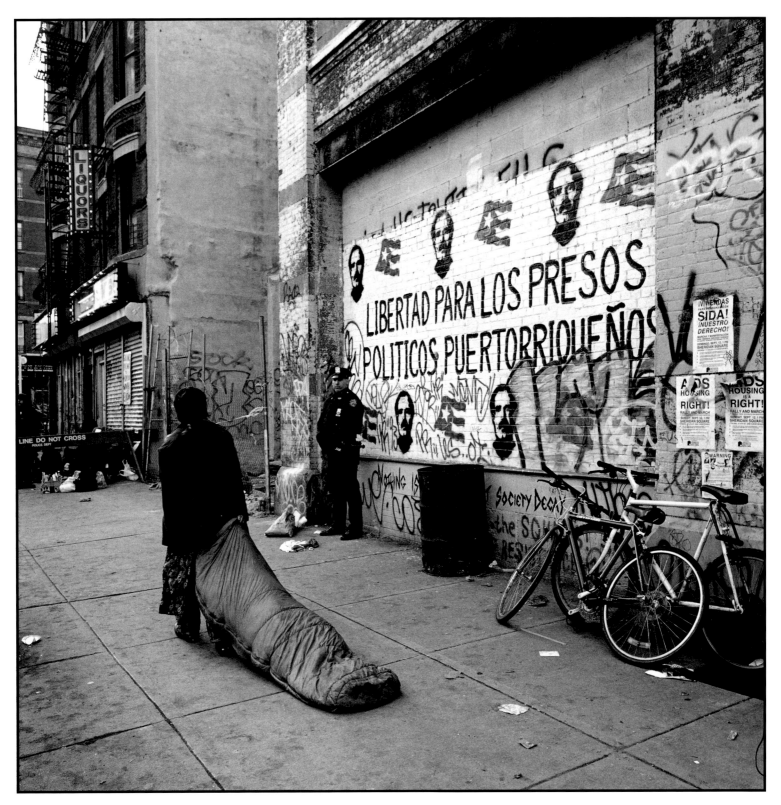

Joeleyn

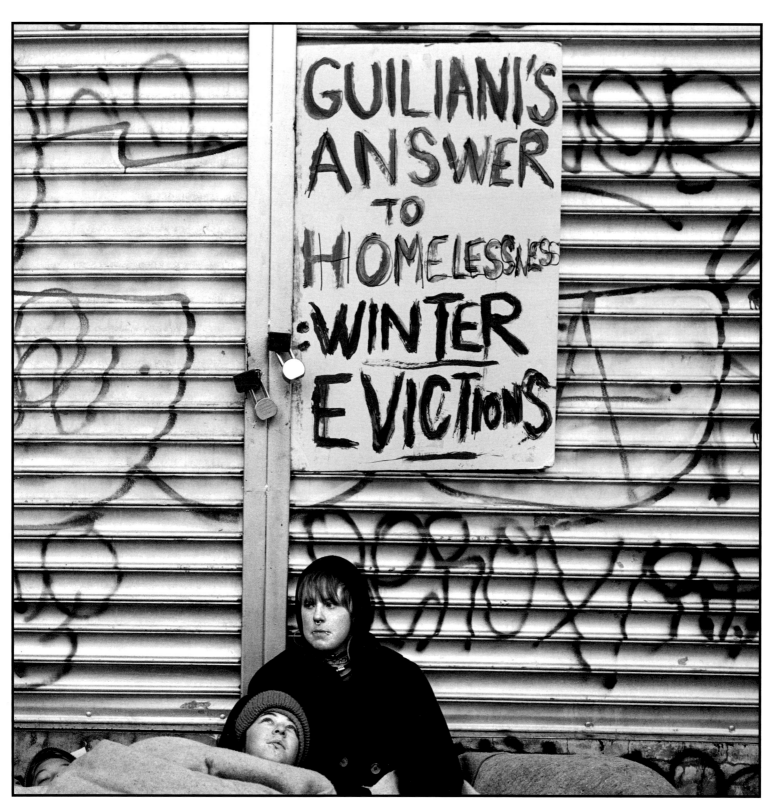

Calli, Maus, and Angela

EPILOGUE

Angela married Jesse in 1997. They live in Indiana with their three children. Jesse is a sergeant in the Army Reserve. They are both active members in the First Assembly of God church.

Calli, her husband, and her daughter moved to Costa Rica to develop a holistic retreat. Calli's puppies, which were rescued from Glass House after an animal welfare organization intervened with the police, continue to live with some of the members.

Chad lives in a squat on the Lower East Side. He has traveled throughout Europe and Brazil, meeting with squatters and street children and painting graffiti and political murals.

Donny lived in a squat on Avenue C. He died from heart disease on October 11, 2002, at the age of forty-five.

Erica lives in Washington State with her daughter and her husband, Log, whom she met at Glass House.

Exodus is believed to have moved to California.

Garth, who now has a daughter, is a fisherman on the Oregon coast.

Joeleyn lived in squats in Philadelphia and Kansas. She and her daughter currently reside in Illinois, where she studies glass and metalwork at the University of Illinois.

John still lives in New York City.

Heidi returned to Wisconsin.

Karl lives in Serenity squat on the Lower East Side.

Kim is an herbalist in Beacon, New York. In 1999, she married Moses, whom she first met at Glass House. They now have two children.

Linda died of a drug overdose in 1996 at the age of forty.

Lisa moved to Colorado, where she earned a bachelor's degree in equine industry and works with horses.

Mark [Gentle Spike] lives in New Orleans.

Markus was killed in a motorcycle accident in Minneapolis on October 21, 1996. He was twenty-two years old.

Maus lives in Illinois with her husband and two daughters. She is an undergraduate student at the University of Illinois.

Merlin slept under a plastic tarpaulin at the corner of Avenue A and East Sixth Street, where he read books and conversed with passersby until a few days before his death, at the age of forty-one. He died from liver failure and internal bleeding on August 16, 1996, at Beth Israel Medical Center. More than 150 people attended his memorial service.

Moses, who married Kim, is currently a sound engineer at the United Nations.

Scott lives in Ohio, where he works installing alarm systems.

Toby lives in Hawaii with her boyfriend and her daughter. She currently is working toward a bachelor's degree in education.

Tyrone lives in New York City and is a freelance photographer.

Some names have been changed and all surnames have been omitted out of respect for individual requests for anonymity.

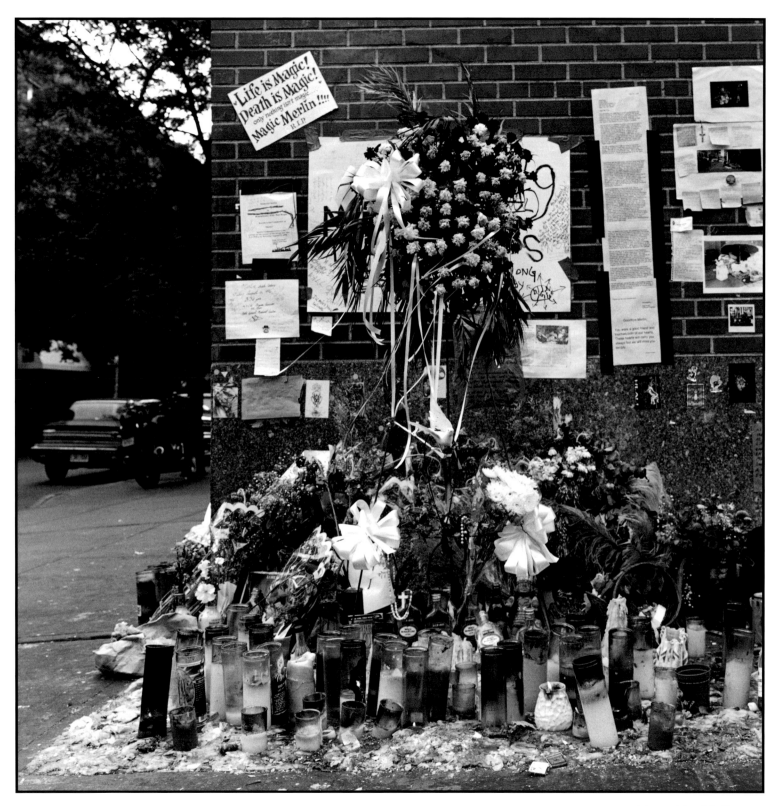

Memorial to Merlin, 1996

Glass House was renovated in 1999 as a supportive housing residence for low-income individuals living with HIV/AIDS. It is called "The Glass Factory."

On August 19, 2002, the Bloomberg administration turned over eleven Lower East Side buildings to the squatters who had been living in them. The new homeowners included Chad, Donny, and Karl.

AUTHOR'S NOTE

The story of Glass House *begins with a chance encounter. In 1993, I was walking down Avenue B when I met John, whom I had photographed at Foetus squat. He told me about a community living in a derelict factory two blocks away.*

A few days later, in Tompkins Square Park, John introduced me to Karl and Gentle Spike, who agreed that if I were interested in documenting Glass House, I should attend their next house meeting to ask for the cooperation of the entire group. I showed them my first book, Transitory Gardens, Uprooted Lives, *at that meeting in a dim, unheated room. They passed it around; they talked and voted. I had entered the world of Glass House.*

From that evening in October until the eviction in February 1994, I attended Sunday night house meetings and Thursday workdays and met with individual members to photograph them and audiotape their stories. After the eviction, I put my photographs, transcripts, and notes aside. A letter from Angela in 1999 prompted me to try to make contact with the other squatters, now widely dispersed, and make a final effort to bring Glass House *to conclusion.*

As the East Village continues to be gentrified at a pace that threatens to erase all memory of its history as a home for ethnic groups and the radical fringe, the time seems right to present this chronicle of a group of young people who crafted a community in an abandoned building at the margins of New York City.

ACKNOWLEDGMENTS

This book would not have been possible without the generosity and trust of the Glass House community. I am deeply grateful to its members, who granted me many hours of their time and allowed me to present the story of Glass House.

A number of other people were essential to the publication of this book. Lissa Margulies printed the gelatin silver prints reproduced in Glass House; *Kathy Kennedy provided earlier technical support. Christine Beardsell and Lucy Leirião, Cooper Union student interns, transcribed many of the audiotapes; Tiffani Casteel Replogle and Brent Schumann, also interns, scanned photographs for the maquette.*

Steven H. Jaffe, senior historian at the New-York Historical Society, shared his expertise on several occasions when I was researching and writing my account of the glass factory and the Lower East Side. Kenneth R. Cobb, director of the Municipal Archives, also offered helpful advice.

Luc Sante and Alan Trachtenberg provided invaluable counsel and encouragement in their responses to the manuscript for this book.

Gloria Kury, my editor, deserves a special debt of gratitude. Glass House *benefited greatly from her imagination and intellect. Cherene Holland and Jennifer Norton provided expert editing, design, and production.*

I have also had the good fortune to receive important insights from my colleagues, friends, and family, including Georgette Ballance, Diana Balmori, Gail Buckland, Peter Buckley, Brian Drolet, Barbara Epler, Mike Essl, Jilleen Johnson, Roy S. Kaufman, Seth Kaufman, William H. Knull III, Yolanda C. Knull, Mindy Lang, Lloyd Miller, Janet Odgis, Judith Orsine, Margi Reeve, Sigrid Rothe, Norman Sanders, Barbara Spackman, Maren Stange, Peggy Wade, and Bonnie Yochelson.

GLASS HOUSE

*has been typeset in Minion Roman and Italic with
Frutiger for display and is printed on
Galerie Art Silk (processed* TCF*)
at The Stinehour Press in Lunenburg, Vermont*